Classic Portrait
Photography

TECHNIQUES AND IMAGES FROM A MASTER PHOTOGRAPHER

William S. McIntosh

AMHERST MEDIA, INC. ■ BUFFALO, NY

On the Cover

The concept for this portrait of JoAnn Falletta was to get the entire audience (over 2000 people) in focus in the background and JoAnn conducting in the foreground. Because this portrait would have been very difficult to make during a concert, JoAnn was photographed in rehearsal the morning of the concert. The audience was then photographed just before the curtain rose at 8pm for the concert. They were informed that I had photographed JoAnn that morning and the finished result would be a one-of- a-kind image of JoAnn conducting and the audience included in the finished portrait.

Fuji NPH 400 film was just the film to meet the challenge of lighting the people in the audience so that you could see most of their faces in a 30x40-inch portrait while keeping them subdued enough that they would not overwhelm the conductor. The film allowed me to make my exposure at f-11, which was just right to get the depth of field needed. The soft contrast of the film allowed me to get more detail in the very dark areas of the symphony hall and the audience. Had I used Fuji NPS 160 film, I would have needed much more light; with Fuji NPZ 800 film, I could have made the portrait in the same light, but the contrast would have been higher.

Digital retouching artist Patricia Van Becelaere accomplished an awesome task on this portrait. There were a number of empty seats in the hall, so Patricia moved people that could not be seen behind the conductor and filled the empty seats with them. Some of the people close to the lights were a little light and some in the back were a little dark. I exposed for the dark areas and Patricia evened out the tones to the depth I needed, showing off the conductor and the audience at their best. Patricia Van Becelaere can be reached at pvan@kc.rr.com.

(**SUBJECT**—JoAnn Falletta, Conductor and Music Director of the Virginia Symphony and the Buffalo Philharmonic Orchestra; **DATE**—2002; **CAMERA**—Mamiya RZ67; **FILM**— Fuji NPZ, ISO 800 [on JoAnn] and Fuji NPH 400 [on audience]; **LENS**—140mm [on JoAnn] and 50mm [on audience])

Published by:
Amherst Media, Inc.
P.O. Box 586
Buffalo, N.Y. 14226
Fax: 716-874-4508
www.AmherstMedia.com

Publisher: Craig Alesse
Senior Editor/Production Manager: Michelle Perkins
Assistant Editor: Barbara A. Lynch-Johnt

Library of Congress Card Catalog Number: 2003112488

Printed in Korea.
10 9 8 7 6 5 4 3 2 1

Notice of Disclaimer: The information contained in this book is based on the author's experience and opinions. The author and publisher will not be held liable for the use or misuse of the information in this book.

DEDICATION

This book is dedicated to my daughter Leslie McIntosh Bullerjahn and my son-in-law Harald Bullerjahn. Leslie and Harald joined my 53 year-old portrait studio four years ago to help carry the McIntosh tradition into the 21st century. Their work has been outstanding, and there is no doubt that McIntosh Portraits will be around for many years to come.

TABLE OF CONTENTS

The portraiture I produce today is much more involved than the year I started in 1950. At that time, nearly all portraits were produced by hand by the photographer. Today, most portraits are completed in a color lab. They are custom printed, with artwork handled by an artist using an airbrush, oils, and pastel pencils, or by another specialized artist that uses digital retouching on a computer.

Ninety-five percent of the portraits in this book were printed by H&H Color Lab. My contact there, who spent many hours consulting with me and getting my work just right, was Sharon Jergen, Marketing and Sales Manager. Most of the traditional artwork was accomplished by Julie Snyder of H&H.

Two independent digital artists, Kyoko Crawley (Seattle, WA) and Patricia Van Becelaere (Greenwood, MO) also spent a considerable amount of time making my work look its best.

Nate Accordo of Custom Color Lab was kind enough to print some of my portraits and have Dee Connell do traditional artwork on them. Nate has been a good friend over the years and has always been helpful.

Carl Anderson of Hampton Roads Color (Virginia Beach, VA), is another friend in the color lab business and makes my prints that do not need art work and finishing.

Operating a portrait business requires a number of skills to make it successful. I am fortunate that I have had my wife Luci to assist me in the day-to-day decisions and business activities that I would be hard pressed to do alone. My daughter Leslie and son-in-law Harald have also taken some work pressure off me, so I could write this book. They have helped me make many of the sittings in this book.

A lot of my portrait sessions are complicated; they require moving furniture, artifacts, plants, etc., around a room or office. Usually I need to set up at least four lights. I have a lot of photographer friends around the country, and I can usually get one or two of them to help me make my sittings. I travel to several cities every year, and I would like to thank the photographers who have taken their time to come along with me on some selected sittings. Photographers that have helped me over the years include:

Virginia Beach, VA Area:
Neal Chavas, Lee Poe, Jeff Kaiser, Barbara Wool, Harriet Coker, Skip Jones, Marcus Holman, Marshall Weathers, Paul Trahadias, Jerry Kelley, Herb Walls, Doris Ross, and Fred Havens.

Washington, D.C. Area:
Bob Zurker, Clay Blackmore, Elaine Studley, Michelle Repiso, George Allan, Dale and Donna Demmick, Yale Silon, and Steve Swain.

Dallas, TX Area:
Jim Duncan, Gary Barnes, Norma Babbitt, Doug Warner, Chris Walden, and Howard Pearlman.

London, England:
Chris and Hillery Hare.

On a personal level, my wife Luci has always been involved in my decisions in business, writing, and everything else. My daughters Lee Ann Wood, Lisa Herbert, and Lori McIntosh worked in my business from their early teenage years until they left for college and many times beyond college. Lisa Herbert, in recent years, has return-

ed from time to time to help when needed. I have been blessed with a close and supportive family.

Don Swift, a lifetime friend and president of Wyndham-Leigh Portraits, has made it possible for me to make some of my finest portraits in the Washington, D.C. and Dallas, TX areas.

Since 1990, the Fuji Photo Film Corporation has been a great supporter of my portraiture. They have used a lot of my work in their ads and promotions. I believe all their products are first class. Some of my portraits would not be as technically correct as they are without their superb films with the four color-layer technology.

The Mamiya America Camera Corporation has sponsored my photography in some of their ads and published my first book, *Location Portraiture: The Story Behind the Art*. I have used their cameras and lenses since 1970 and their Profoto for special shoots.

The Bogen Photo Corporation has helped keep my Gitzo tripods and ball-joint head in good working order.

In chapters 3 and 4, the backgrounds used in some of the portraits are by Maheu (483 Steere Farm Road, Harrisville, RI 02830) and The Background Lady (1535 E. State St., Rockford, IL 61104).

Finally, I would like to mention that some of the portraits in this book, and some of the discussions, have been previously published in photographic magazines, including *Professional Photographer, Rangefinder, Lens, The Creative Image* (British) and *The Master Photographer* (British).

CLASSIC PORTRAITURE: ALWAYS IN STYLE

by Peter Skinner

Classics, whether they are suits, movies, or books, simply never go out of style. If something is good—*really* good—it will stand the test of time. And that can definitely be said of the portraits created by one of the masters of the genre, William S. McIntosh.

For more than 50 years, Bill McIntosh has been carving his name in the annals of portraiture, setting himself ever higher artistic and professional goals. His mission statement, and the one on which he has based all his work, is simple: "If I am going to put my name on it, it will be the very best that I can do. I will not leave a portrait session until I know I have done my best to make the customer happy."

Recently, he was named by the prestigious English publication *Creative Image Magazine* as one of the five best portrait photographers in the world. It is not an honor that McIntosh himself necessarily subscribes to, quickly pointing out that such distinction is purely subjective.

That aside, however, it is indicative of the esteem in which his work is held, both in the U.S. and internationally. McIntosh has garnered many awards and honors. He holds PPA's Master of Photography, and is a Fellow of the American Society of Photography, the British Institute of Professional Photography, and the Royal Photographic Society of Photography. He is also an Honorary Fellow of the Master Photographer's Association. While recognition from organizations such as these is rewarding, McIntosh's goal has been making the people in front of the lens happy with their portraits. The reason is simple: if they don't like the results, the photographer does not stay in business.

McIntosh's entry into photography began in 1947 (in the aftermath of World War II, during which he was stationed in Japan) and took advantage of the GI bill, which had been doubled at that time to make military service more appealing. Young Bill McIntosh was certainly frugal, as well as a little lucky and undoubtedly ambitious. The lucky part was winning a 35mm rangefinder Clarus camera with a 50mm lens in a PX raffle. He then used a variety of innovative and commercially oriented ploys to obtain film. He began documenting his postwar Japan experience. Film was hard to come by, and McIntosh treated each exposure with the attention it deserved. For example, he took about two

CLASSICS, WHETHER THEY ARE SUITS, MOVIES, OR BOOKS, SIMPLY NEVER GO OUT OF STYLE. IF SOMETHING IS GOOD—REALLY GOOD—IT WILL STAND THE TEST OF TIME.

weeks to expose one roll of film, at times going for two days or more before making a picture, even though he was looking for images the whole time. "I wrote a script of everything I wanted to photograph to record my experience in Japan and I took my time, making sure I got everything on the list on the one 36 exposure roll," he says. From this venture he sold some 200 sets of prints, making about $200 in the process. Not bad for a young soldier who had yet to finish high school.

While in Japan, McIntosh benefited from another source, a book which not only inspired him, but instilled within him aspirations of striving for the very best in portraiture. The book was Yousuf Karsh's *Faces of Destiny* (Ziff-Davis Publishing, 1946), portraits of wartime leaders such as Winston Churchill, Lord Mountbatten, and Eisenhower. "The portraits in that book became my ideal and I

most to advance the craft. These are Julia Margaret Cameron (born in England in 1815 and considered the finest early portrait photographer), Edward Steichen, and Arnold Newman.

While maintaining that he could never get access to international figures such as Karsh photographed for his *Faces of Destiny* project, which was funded by the Canadian government, McIntosh has photographed an impressive list of international dignitaries and leading citizens of Virginia—virtually the aristocracy of Virginia—including statesmen, politicians, military leaders, writers, and photographers. Among his subjects are Colgate Darden, a governor of Virginia and one of the state's outstanding leaders; well-known New York political figure Mario Cuomo; Richard Gasso, Chairman and CEO of the New York Stock Exchange; General Colin Powell, currently Secretary of State but at that time chairman

traits he made of celebrated contemporary photographers, including Yousuf Karsh, Arnold Newman, Jay Maisel, Gordon Parks, Aaron Siskin, Alfred Eisenstadt, and Cornell Capa, which were exhibited in the International Photography Hall of Fame in Oklahoma City. Portrait photographers will resort to all manner of antics and chitchat to get the most out of a session, and McIntosh used his own brand of outrageous humor and other ploys when working with his colleagues in the famous photographer series—with great results.

In his career, McIntosh has achieved a long-term goal, upgrading his portrait photography to an art form and being recognized as an artist. In 1964, he photographed the leading 22 painters in Virginia, and the portraits were displayed in an exhibit together with examples of the artists' work. An excellent review by a local art critic led to the director of what is now the Walter Chrysler Museum inviting McIntosh to exhibit in the museum. The theme for that first museum exhibit in February 1968 was "The Cultural Life of Norfolk," which included portraits of painters, symphony principals, and ballet performers. The exhibit was such a success that it opened many other doors, and McIntosh was able to organize theme exhibits to hang in bank lobbies, librar-

MCINTOSH USED HIS OWN BRAND OF OUTRAGEOUS HUMOR AND OTHER PLOYS WHEN WORKING WITH HIS COLLEAGUES IN THE FAMOUS PHOTOGRAPHER SERIES . . .

wanted to make pictures like them. From then on, I worked at full speed, but it took me until the mid-to-late 1950s before I reached the quality that I sought," he says.

McIntosh credits Karsh and three other great portrait photographers as having done the

of the Joint Chiefs of Staff; writer Tom Wolfe; writer David Baldacci; TV commentator Larry King; legendary baseball great and baseball Hall of Fame member Yogi Berra; and numerous other well-known figures.

One of his favorite self-assignments was a series of por-

ies, schools, and large shopping malls. His portraiture had become wall art, now hanging in many places traditionally dominated by paintings. For example, canvas prints of his portraits hang in the Federal Court House, the Pentagon, Annapolis, and Old Dominion University. In September 2001, a 50 year retrospective of his work was exhibited in the Chrysler Museum, the institution which opened its doors to him in 1968.

Bill McIntosh began his business and marketing plan when he returned from Japan to complete high school and began to take pictures for the school yearbook. At that time, yearbooks were a low-end product, and the photography was mediocre at best. As luck would have it, the student advisor in charge of yearbook production wanted to upgrade the publication. Says McIntosh, "She wanted to produce an award-winning yearbook." In young Bill McIntosh she found the ideal, go-for-it photographer. His style caught on, and soon he was the yearbook shooter for all seven local schools. Over time, McIntosh and his team picked up all the schools in the Norfolk and Virginia Beach area, eventually dominating the market for 31 years. The timing was impeccable. In those postwar years, the number of high-school seniors increased by about 20 percent a

year for 20 years, creating an ever-expanding market.

And schools were not McIntosh's only market—portraits, children, pets, and a variety of other commercial subjects became part of his far-reaching operation, which included three studios employing 40 people. In 1981, McIntosh sold the business, a move that allowed him the freedom to focus on what he loves best: portraiture on location, and especially executive portraiture. Today, his work is mostly on location, with some exclusive sessions made on 4x5 film for large, wall-size portraits.

With his daughter Leslie, McIntosh operates a studio by appointment only. He devotes most of his time to location assignments. And when on location, he spares no effort to light the subject and the environment to his own demanding requirements. He uses a combination of ambient light, numerous flash units, reflectors, and umbrellas. His lighting is both classic and contemporary—and he still uses Polaroid film for testing. Whatever it takes, he will use. As of this writing, digital portraiture on the highest level for large, wall-size prints has not matched the quality of film. He believes it will fairly soon, but it will still be some time before it is economi-

cally practical for the high-end portrait artist with a low volume of work.

The advice McIntosh would offer young photographers, based on his own modus operandi, is to learn as much as you

HIS PORTRAITURE HAD BECOME WALL ART, NOW HANGING IN MANY PLACES TRADITIONALLY DOMINATED BY PAINTINGS.

can about the subjects beforehand—including getting biographies and current portraits of civic leaders and other public figures so you have a foundation for down-to-earth conversation and communication during the session. Then, strive to make a positive and uplifting visual statement about the people you photograph. It's worked for Bill McIntosh for more than half a century, and it continues to work for him today.

Peter Skinner *is a contributing editor to* Rangefinder *and* Photographic *magazines, and his articles have appeared in other photographic publications including* Outdoor Photographer *and the European magazine* Opticon. *From 1991 to 2003 he served as publications editor and communications director for the American Society of Media Photographers (ASMP). He is also an accomplished photographer whose images have appeared in numerous publications in the U.S. and abroad.*

WHAT IS A CLASSIC PORTRAIT?

The term "classic" brings up several questions. What is a "classic portrait"? Why is one portrait considered a classic while others are not? Is a classic portrait a work of art?

The word "classic" implies timelessness. There are five elements that elevate a portrait from one that is merely a pictorial record to one that has a timeless quality:

1. **Design**—Design is your concept or idea of where the portrait is going to be made, the space or background you will use, and what artifacts you may wish to include in the portrait to reflect the lifestyle or preference of the subject. Composition is also part of design. It defines how you will arrange the subject and other elements in that space to form a complete visual statement.

2. **Pose**—The pose refers to your consideration of how and why and where the subject is positioned after you have decided on the location.

3. **Color Harmony**—This is the blending of the colors of clothes, furniture, plants, artifacts, and background, to make a pleasing portrait.

4. **Expression**—The finest portrait is a failure without a good expression. The expression should reflect the mood or personality of the subject that you want to show.

5. **Lighting**—The proper, artistic use of light can make a good portrait extraordinary.

Is a classic portrait a work of art? Art means different things to different people and, like beauty, often is in the eye of the beholder. But a work of art is something that stands the test of time. I would say that a fine portrait is definitely a work of art.

THE BLACK & WHITE STUDIO PORTRAIT
(1950–1964)

In 1950, DeWint Baker Hood and I opened a modest portrait studio in Norfolk, VA. DeWint was only with me for one year, when he decided to return to New England. The equipment we bought when we opened was a used 8x10-inch Kodak studio camera with a used 14-inch Kodak Ektar lens, a full 5x7-inch back that could be used with 5x7-inch film and a shift back, making two 3½x5-inch negatives on a sheet of 5x7-inch film. The lighting was two tungsten Photogenic lights with 1,000 watt bulbs in 20-inch reflectors with spun glass covering the reflectors to diffuse the light. One unit served as the fill light, the other was the main light and had barn doors attached for better control. Two Photogenic 200-watt tungsten mini-spots were used, one as a hair light and one to light the background. The film we used was black & white Kodak Super Pancro Press Type B with an ISO of 125. One hundred sheets of this 5x7-inch film cost $8.50.

In 1950, nearly all the studios in the U.S. were using black & white film and tungsten lights. Perhaps two or three were using the Kodak dye-transfer color print process using color transparency film. The top-of-the-line studios used full 5x7-inch film and a few used 8x10-inch film for full-length bridal and group portraits; most others used split 5x7-inch film. Most everyone developed their own film, made their own prints in the darkroom, and retouched and spotted their own prints.

From the end of World War II until the late 1960s, the Eastman Kodak Company employed some of the finest masters of photography in the country as studio technical representatives. Because there were few schools of photography in the 1950s, most of the photographers getting started after WWII received much-needed help from the Kodak technical representatives on how to make portraits using Kodak products (at that time, over 80 percent of all photographic products were Kodak).

Our Kodak technical representative was Ralph Bray, a master of photography and a WWII

BECAUSE THERE WERE FEW SCHOOLS OF PHOTOGRAPHY IN THE FIFTIES, MOST OF THE PHOTOGRAPHERS GETTING STARTED AFTER WWII RECEIVED HELP FROM KODAK TECHNICAL REPRESENTATIVES.

veteran who decided to be a Kodak representative rather than return to his home in Kansas City, MO, to start over again with a studio after the war. Ralph taught me, and many others in Virginia, how to make fine portraits and get started in portrait photography.

Success

It was almost ten years before I was able to approach the quality of the black & white portraits I had admired of Yousuf Karsh. In the '50s and '60s, few studios made environmental location portraits. To customize their images, they used painted backgrounds and furniture—and sometimes had the customer bring in a favorite piece of furniture, artwork, or some other object they were fond of for their portraits.

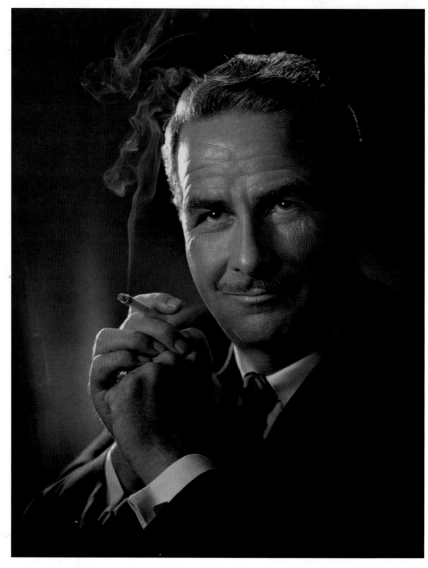

RIGHT—My first successful attempt at Karsh-type lighting was a portrait of Paul, a personal friend. I had to use friends for my early attempts, because I had to have them sit still for a long time while I used trial and error to get the lighting and posing right. I made a lot of portraits with lit cigarettes—in those days, just about everyone smoked. By 1958, I had switched from tungsten lights to Photogenic strobe lights. I used a studio camera with a 5x7-inch Super Pancro Press Type B, ISO 125 film, and a 14-inch Ektar lens. Two main lights were used. One was a spotlight strobe about 90 degrees to the left of the camera. The second, the fill light, was a diffused 20-inch reflector with barn doors almost 90 degrees to the left. One spotlight strobe was placed 135 degrees to the left rear, and another spotlight strobe was used as a hair light. A background light illuminated the background and a 4x4-foot white reflector was placed to the right of the camera to fill in the shadows. (**SUBJECT**—Paul Woodward, architect; **DATE**—1958; **CAMERA**—8x10-inch Kodak studio camera; **FILM**—5x7-inch Super Pancro Press Type B, ISO 125; **LENS**—14-inch Ektar)

FACING PAGE—George was another friend who spent a morning posing for me. He brought his Turkish engraved coffee table and we mounted it on the wall behind him. The setup for the strobe lights was similar to that used in the previous image, but the 20-inch strobe was placed 90 degrees to the left of the subject. (**SUBJECT**—George Whitehurst, interior designer; **DATE**—1958; **CAMERA**—8x10-inch Kodak studio camera; **FILM**—5x7-inch Super Pancro Press Type B, ISO 125; **LENS**—14-inch Ektar)

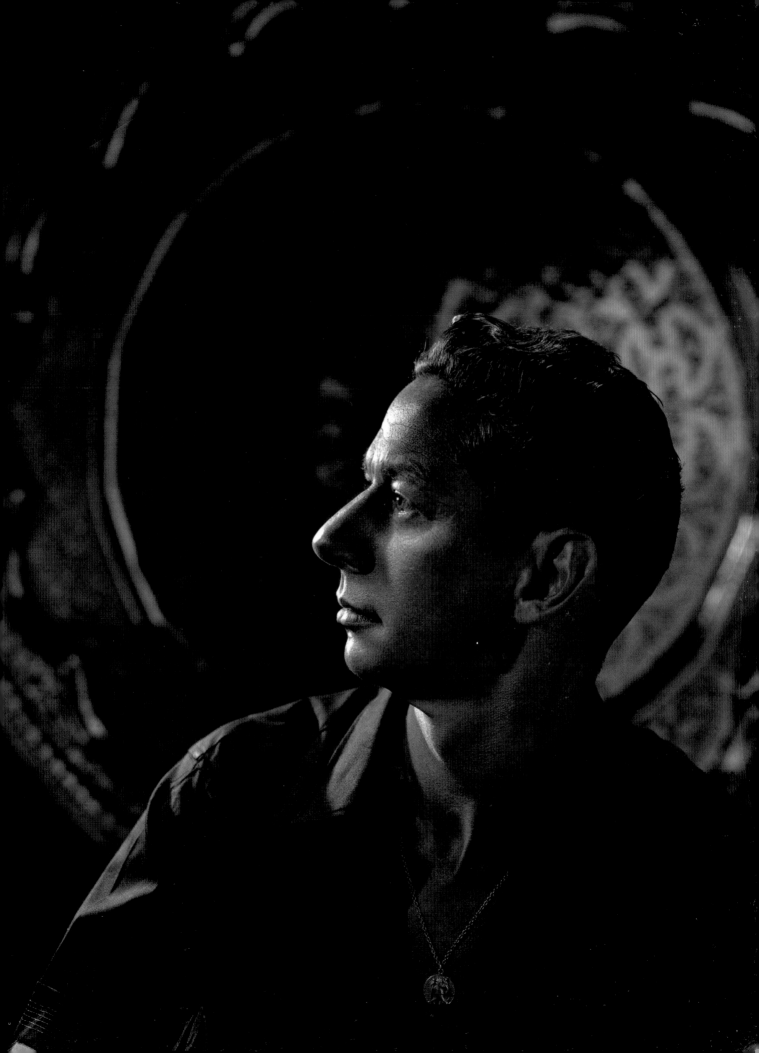

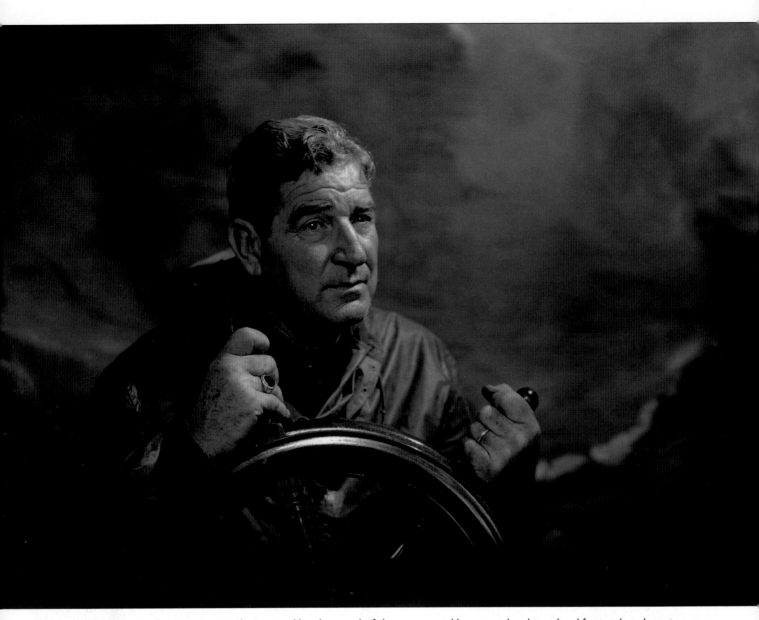

ABOVE—For this image, I used a painted background of the ocean and borrowed a ship wheel from a local marine supply house. The lights are similar to those used in the first image in this chapter, but the lights were placed to the right instead of the left. (**SUBJECT**—Paul Hammick, retired Chief Petty Officer, United States Navy; **DATE**—1959; **CAMERA**—8x10-inch Kodak studio camera; **FILM**—5x7-inch Super Pancro Press Type B, ISO 125; **LENS**—14-inch Ektar)

FACING PAGE—Ralph and I set up an all-Kodak background for his portrait. Again, the lighting used was also similar to that discussed for the first image in this chapter, except the spotlight was placed 60 degrees to the left instead of 90 degrees. (**SUBJECT**—Ralph Bray, Kodak technical representative; **DATE**—1963; **CAMERA**—8x10-inch Kodak studio camera; **FILM**—5x7-inch Super Pancro Press Type B, ISO 125; **LENS**—14-inch Ektar)

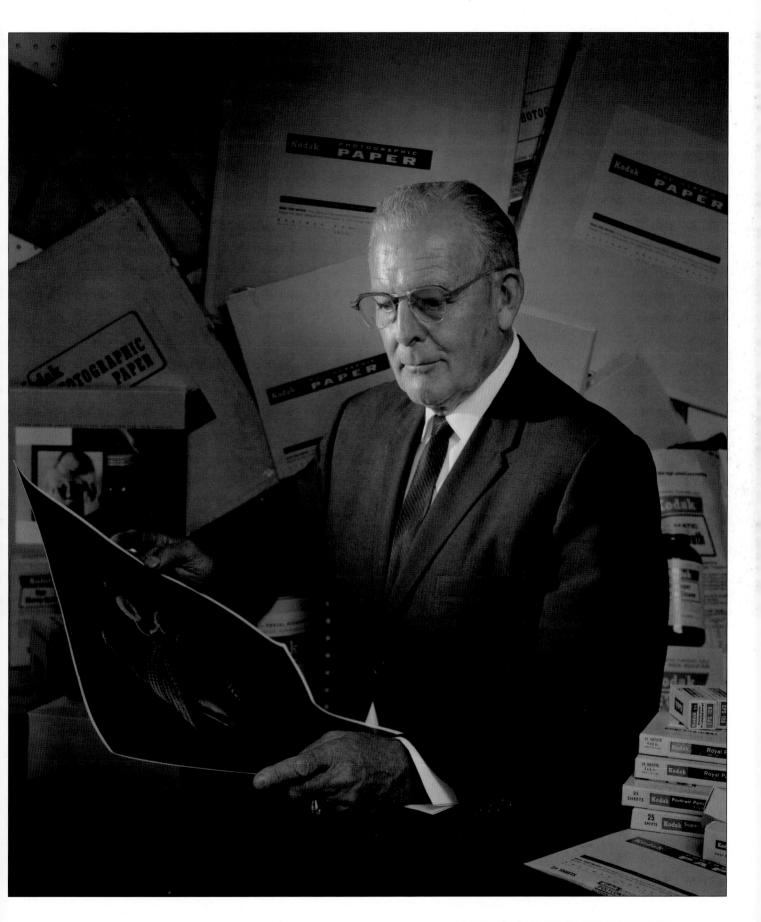

ABOVE—Tracey Creech is a friend of my daughter Lisa. I made this portrait as a background for a color portrait I made of Tracey in an evening gown, to show the contrast between a feminine pose and a masculine one. Four strobes were used: two 7-inch reflectors with barn doors were placed about 135 degrees from the right and left rear, another 7-inch reflector with barn doors was placed 90 degrees to the subject's left, and a 31-inch umbrella fill light was behind the camera. (**SUBJECT**—Tracey Creech; **DATE**—1990; **CAMERA**—Mamiya RZ67; **FILM**—Kodak T-Max, ISO 100; **LENS**—180mm)

FACING PAGE—I met Harry at a party and asked him to pose for me. The lighting was also the same as that used in the first portrait. (**SUBJECT**—Harry Reid, math teacher; **DATE**—1964; **CAMERA**—8x10-inch Kodak studio camera; **FILM**—5x7-inch Super Pancro Press Type B, ISO 125; **LENS**—14-inch Ektar)

CHAPTER THREE
THE COLOR STUDIO PORTRAIT

If I had to put a date on when color portrait photography started to overtake black & white in the studios of the country, I would say it was in the early 1970s. At that point, the school portraits for most grammar schools and high-school seniors had already shifted to color. The older studios that were traditionally black & white were also offering color, and color was offered almost exclusively in most of the new studios opening for business in the early 1970s.

Medium Format
The Mamiya RB67 camera came on the market in 1970. With its revolving back and variety of lenses, it quickly became the standard camera to replace the bulky old studio cameras in studios all over the country. The RB67 along with the newer Mamiya RZ67 camera are still the foremost studio cameras in use today. Indeed, most portrait studios today still use cameras that are either 645, 6x6cm, or 6x7cm format. With the variety and exceptional quality of film available today, this is a wise choice. Fine portraits can be made up to 30x40 inches from these formats.

Nearly all my portraits since 1981 have been environmental portraits made on location. Four years ago, however, my daughter Leslie joined me in business. With the increased volume she helped generate, we had to open a studio. Today, the vast majority of portraits we make in the studio are still created with the Mamiya RZ67. I also use it for executive and group portraits.

As this book goes to press, I have switched to the Mamiya 645 Auto Focus D for my outdoor portraits. It is about half the size and weight of the RZ67, which is a very helpful thing when you are taking a long walk through sand dunes to create your portrait.

4x5-inch Format
The time came, however, when I knew that I needed a larger format. One of my corporation customers wanted a 40x60-inch portrait for the retiring founder and chairman of the board to fit a space in their lobby. I decided the 6x7cm format would not give me the sharpness and quality I was looking for, so I used my Toyo 4x5-inch field camera with a 210mm lens to make the sitting.

The difference in quality was very apparent. It is hard to describe the extended tonal scale between the deepest black and brightest white. You could see the superiority of the larger format in the sharpness of the image, the detail in the black hair and clothes, and a richer glow in the subject's flesh tones.

A few years ago, three investors and I opened several photography studios in Texas and the Washington, D.C. area. We named them Wyndham-Leigh Portraiture. The studios

These sisters operate an upscale Vietnamese restaurant with their parents. Their parents wanted a large 40x60-inch portrait for the back wall of the restaurant. The main light, set between f-11 and f-16, was a Travelite 750 strobe in a 48-inch white satin umbrella directed 45 degrees to the right of the camera. Two similar strobes with 7-inch reflectors and barn doors were used as skim lights, each placed to the right and left rear of the subjects and set for f-8. The fill light, set between f-5.6 and f-8, was a strobe with half a reflector to direct the bare-bulb light between the white ceiling and wall behind the camera, which was set to f-16. (**SUBJECT**—Sisters and restauranteurs; **DATE**—2000; **CAMERA**—4x5-inch Toyo field camera; **FILM**—Fuji NPS, ISO 160; **LENS**—Schneider f-5.6, 210mm)

are geared to reach high-income customers. My involvement is to travel to the studios as needed, to serve the customer interested in large wall-size portraits. The 4x5-inch format is featured for the 30x40-inch and 40x60-inch portraits.

It stands to reason that the 4x5-inch format, which is over twice the size of the $2\frac{1}{4}$x$2\frac{3}{4}$-inch format, would give a better result in the larger sizes. While it is hard to tell the difference in quality in sizes up to 24x30

inches, when you reach the 30x40-inch and 40x60-inch size, the prints from the larger format negatives really begin to shine.

Still, many high-income people do not buy large wall-size portraits. I have found that there are several reasons for this. One is the price is not high enough to get their attention. Therefore, we offer the large format portrait at a significantly higher price. The cost of 4x5-inch film and proofing is high,

so these portraits *have* to be premium priced—as much as 50 percent or more above most regular portrait prices. If your studio already caters to the upscale customer, adding wall-size images at a premium price has the added benefit of making your regular portraits seem like more of a bargain to your regular customers.

Another reason for slow wall-size portrait sales is that very few studios have 40x60-inch portraits made on large for-

ABOVE—The Addingtons are both fashion models who wanted a personal portrait for themselves, not one that was made for fashion magazines. I posed them on an antique couch in a romantic pose. The main light was a 16-inch reflector with barn doors. Both of the subjects had flawless complexions, so I decided to use the more concentrated and sharper light to get added detail in their faces and hair. The barn doors were used to tone down the woman's left arm and their hands, so they would not compete with their faces. (**SUBJECT**—The Addingtons; **DATE**—2000; **CAMERA**—4x5-inch Toyo field camera; **FILM**—Fuji NPS, ISO 160; **LENS**—Schneider f-5.6, 210mm)

FACING PAGE—Here, Jane Addington was photographed against a tapestry background. A 16-inch reflector was used as the main light. (**SUBJECT**—Jane Addington; **DATE**—2000; **CAMERA**—4x5-inch Toyo field camera; **FILM**—Fuji NPS, ISO 160; **LENS**—Schneider f-5.6, 210mm)

mat film, or have them on display to show the difference in quality. You can not sell what you do not show. In our studio, we display several 40x60-inch life-size individual portraits (not full length) and a 40x50-inch family group portrait. I like to take my patrons up close to one and show them the individual eyelashes, the delicate color in the iris of the eyes, and the lips that look real. I tell the patron that it would take one of the world's finest realist painters about three months to come close to duplicating the smooth, flawless flow of hair and individual threads in the fabric of their clothes.

FACING PAGE—The lighting for this image is the same as for the first portrait in this chapter, except that the main light was a 16-inch reflector. This was used to capture more of the rich character lines in Dan's face. One Travelite strobe with a snoot was directed on the background to separate the area behind his head and shoulders and make him stand out more. (This light would not be necessary if an umbrella, which offers greater coverage, was used as the main light. The concentrated light from the 16-inch reflector, however, did not reach the background.) (**SUBJECT**—Dan Alexander, top salesman in all the Neiman-Marcus stores; **DATE**—2000; **CAMERA**—4x5-inch Toyo field camera; **FILM**—Fuji NPS, ISO 160; **LENS**—Schneider f-5.6, 210mm)

TOP RIGHT—Karla was photographed for a 40x50-inch portrait as a sample of Wyndham-Leigh Studio's life-size portraits. The main light was a 48-inch umbrella, and the flower arrangement was lit separately. (**SUBJECT**—Karla Thomas; **DATE**—2001; **CAMERA**—4x5-inch Toyo field camera; **FILM**—Fuji NPS, ISO 160; **LENS**—Schneider f-5.6, 210mm)

BOTTOM RIGHT—My daughter Leslie was photographed with her husband and daughter. A 48-inch umbrella was used as the main light. (**SUBJECT**—The Harald Bullerjahn family; **DATE**—2000; **CAMERA**—4x5-inch Toyo field camera; **FILM**—Fuji NPS, ISO 160; **LENS**—Schneider f-5.6, 210mm)

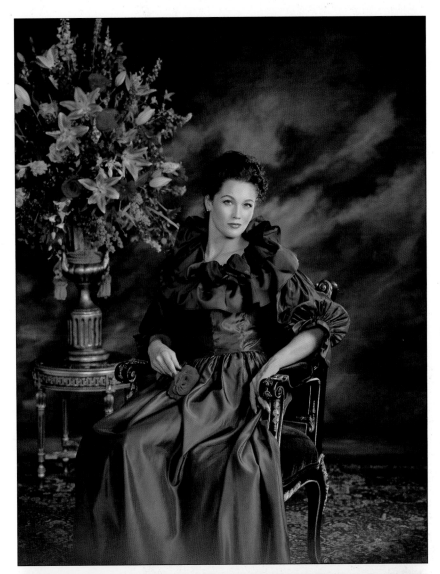

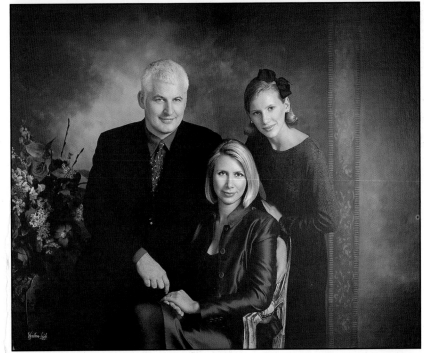

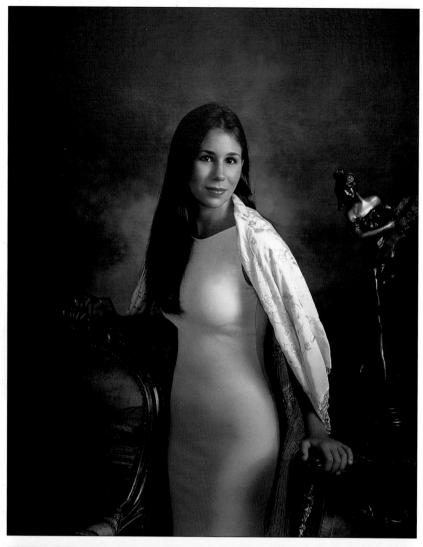

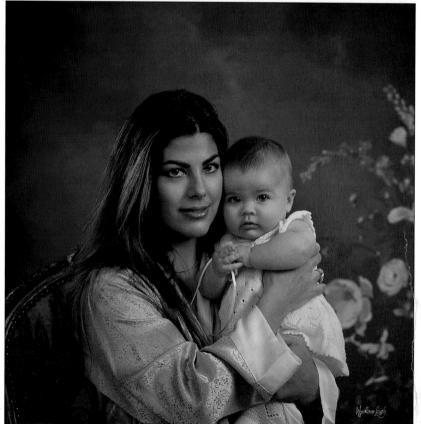

FACING PAGE—This portrait was made over 30 years ago, when the South was not known for its racial tolerance. I have always felt all humans have more in common with each other than there are differences, and there are beautiful people in every race. This portrait was accepted in a public exhibit at a major shopping mall with no criticism at all. I believe art educates everyone. Two strobes in 48-inch umbrellas were used to create this portrait at an exposure of f-16. (**TITLE**—*Three Races* (Judy Lee [top], Terry White [middle], Jeannie Wong [bottom]); **DATE**—1970; **CAMERA**—4x5; **FILM**—Kodak Vericolor, ISO 160; **LENS**—14in. Kodak Ektar)

TOP LEFT—Annie is the daughter of a high-school classmate of mine. She has three siblings, and when each of them turned eighteen years old, I made their portrait. A 48-inch umbrella was used for the main light. (**SUBJECT**—Annie Phillips; **DATE**—2001; **CAMERA**—4x5-inch Toyo field camera; **FILM**—Fuji NPS, ISO 160; **LENS**—Schneider f-5.6, 210mm)

BOTTOM LEFT—I met this beautiful young woman with her angelic little baby in a restaurant and asked the mother to pose for me with her baby. This lovely portrait is the result. A 48-inch umbrella was used as the main light. (**SUBJECT**—Young mother and baby; **DATE**—2000; **CAMERA**—4x5-inch Toyo field camera; **FILM**—Fuji NPS, ISO 160; **LENS**—Schneider f-5.6, 210mm)

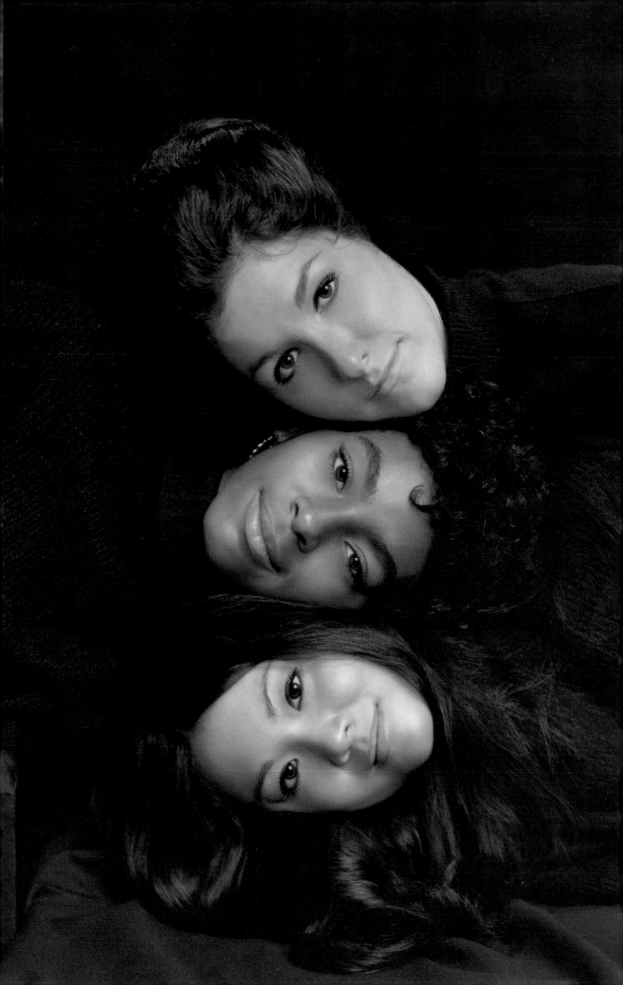

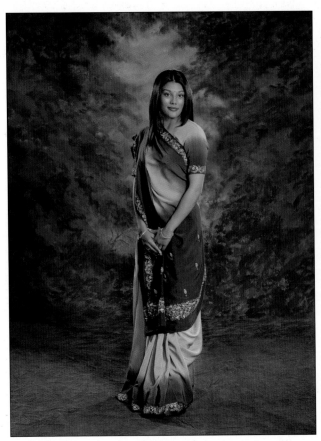

LEFT—Surish was photographed with her family, then I made a separate sitting of Surish with several of her native saris. This is the most striking one, and it is a lovely portrait of a beautiful young woman. A 48-inch umbrella was used as the main light. (**SUBJECT**—Surish Patel; **DATE**—2003; **CAMERA**—Mamiya RZ67; **FILM**—Fuji NPS, ISO 160; **LENS**—140mm)

RIGHT—Twins Jill Jenkins and Jan Arnold are hairstylists who own their own business. Their complexions were just about perfect, so I used the 16-inch reflector with barn doors as a main light. A strobe with a snoot was used on the background. Two skim lights and a fill light were also used. (**SUBJECT**—Jill Jenkins and Jan Arnold; **DATE**—1998; **CAMERA**—Mamiya RZ67; **FILM**—Fuji NPS, ISO 160; **LENS**—140mm)

FACING PAGE—Elaine is a well-known photographer in Washington, D.C., and a good friend. She needed a portrait for a feature article in a Washington magazine and was looking for something a little different. She came to my Virginia Beach studio and we came up with the idea of framing her in two frames. A 48-inch umbrella was used as the main light. I used Fuji NPH 400 film so the exposure could be at f-22 to get the front frame in focus. (**SUBJECT**—Elaine Studley, photographer; **DATE**—2003; **CAMERA**—Mamiya RZ67; **FILM**—Fuji NPH, ISO 400; **LENS**—140mm)

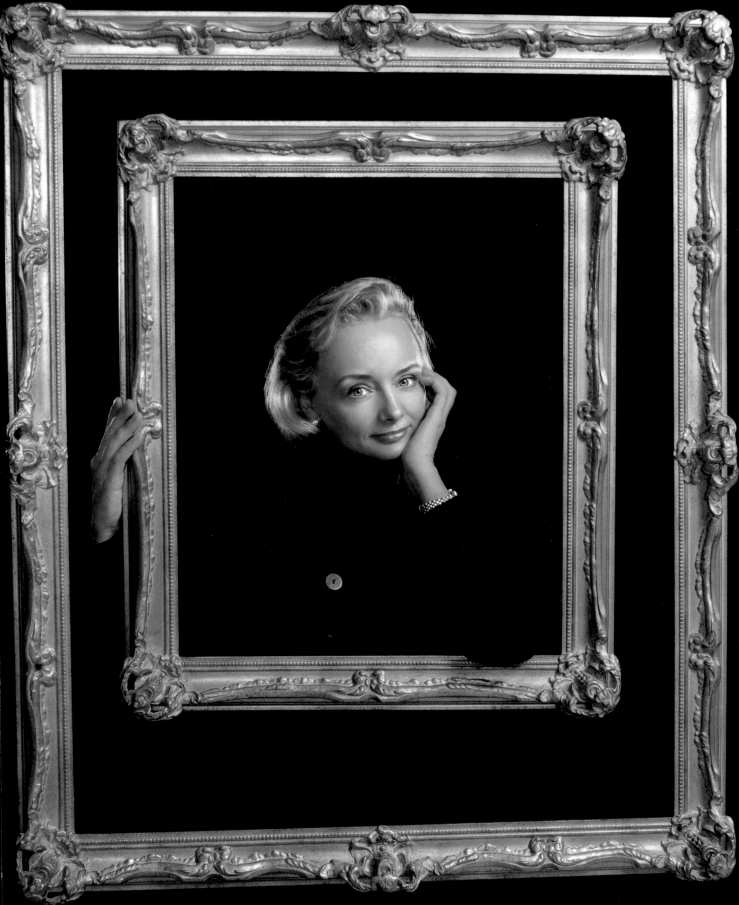

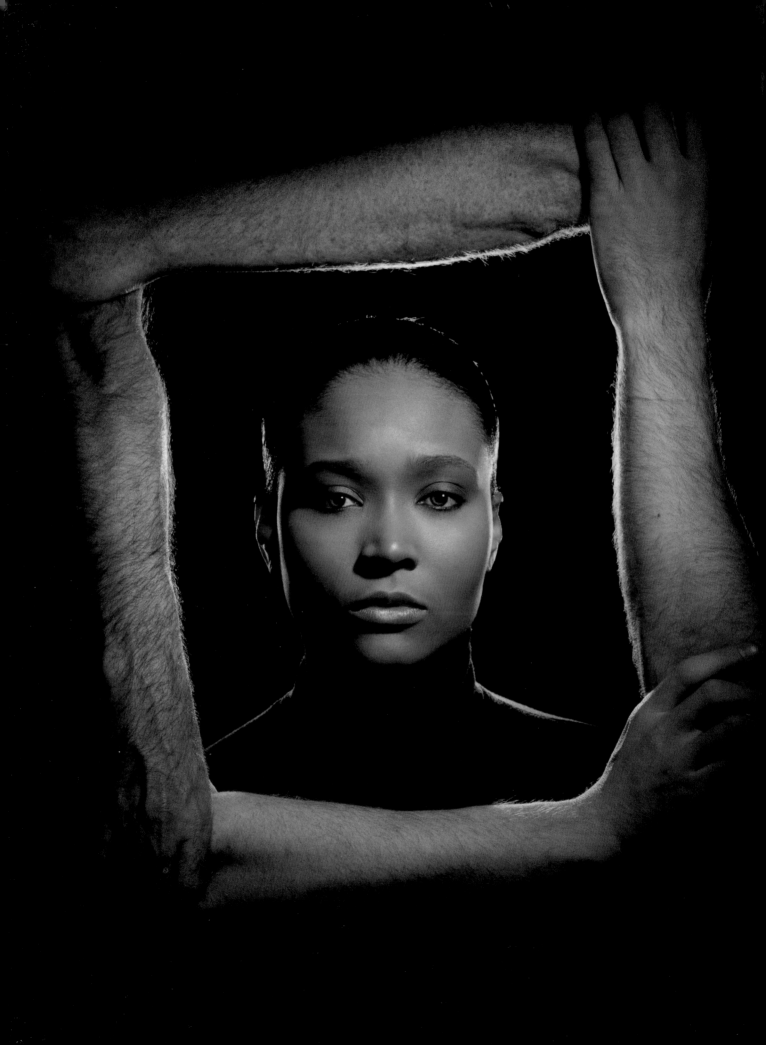

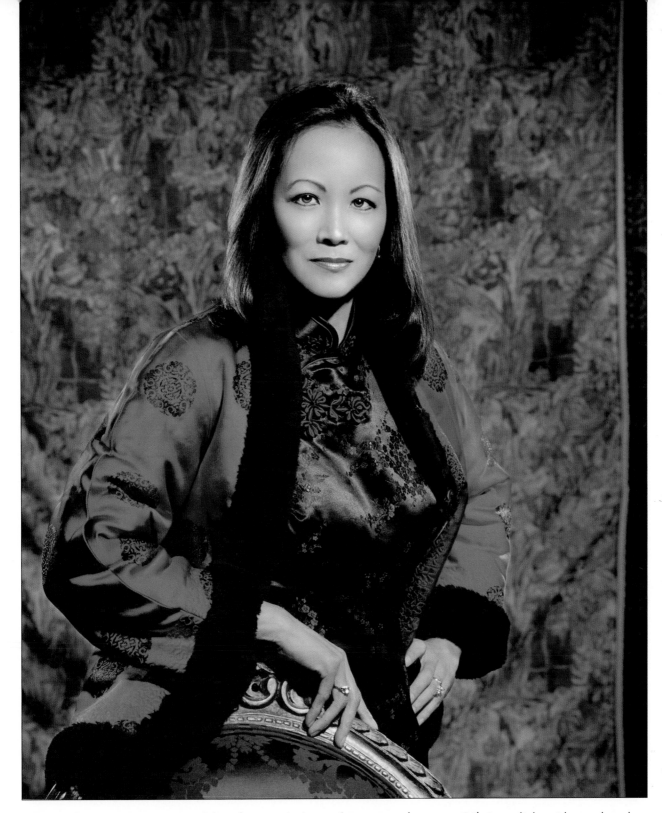

ABOVE—This is a recent portrait of the subject at the base of *Three Races* (see page 25). A spotlight grid was placed on a 7-inch reflector almost directly over her face. Two 7-inch reflectors with barn doors were placed 135 degrees to the right and left rear to light her hair. Another 7-inch reflector with barn doors lit the background. No fill was used. (**SUBJECT**—Jeannie Wong Slaughter; **DATE**—2003; **CAMERA**—Mamiya RZ67; **FILM**—Fuji NPS, ISO 160; **LENS**—140mm)

FACING PAGE—Photographed at the Winona School of Photography in 1988, the arms of four students were used as a frame for the model's face. The main strobe light with a snoot was directed on the woman's face, two strobes with 7-inch reflectors and barn doors were used as skim lights from the right and left rear of the subject, and a 48-inch umbrella was used for the fill light and placed behind the camera. (**SUBJECT**—Model and students; **DATE**—1988; **CAMERA**—Mamiya RZ67; **FILM**—Kodak Vericolor, ISO 160; **LENS**—140mm)

INFLUENCE OF THE VICTORIAN PAINTERS

Queen Victoria was crowned in 1837 and died in 1901. During her reign, the British Empire owned one-fifth of all the land area in the world. Being the first to industrialize, it was also by far the richest country in the world. A large and wealthy middle class was created and, for the first time, they were able to build fine homes and furnish them with fine furniture and art.

In the past, only the royalty and the nobility had been able to afford paintings of themselves and their families, but the new middle class wanted the best of everything and they could afford it. High on their list was portrait paintings. At no time in history was the portrait painter more in demand, celebrated, and financially rewarded than during the Victorian Era. It was during this time that the flattering portrait was perfected. The poses, lighting, storytelling genre scenes and innovative uses of color and design were realized.

Photography was invented and made available to the public in 1839. Early portrait photographers imitated the posing and lighting of the painters of the time. Julia Cameron was the first great portrait photographer of Victorian England, and she was a friend of many artists, writers, scientists, and statesmen—and she made some classic portraits of them. Some of her work is similar to the Pre-Raphaelite painters, but being one of the first to pioneer the close-up and the story telling portrait, she became an original in her own right.

ABOVE—*The Sitwell Family* by John Singer Sargent.

FACING PAGE—*The Sitwell Family* by John Singer Sargent [1856–1925] gave me the idea for this portrait. There are a number of Victorian artists, painter James Jacques Tissot (1836–1902) and photographer Gertrude Kasebier (1852–1934), for example, who placed children in the foreground on the floor and their parents in the background. After a consultation with these clients, I recommended the style of clothes that the girls and their mother should wear to match the decor of the home. I had the flower arrangement made to match the warm colors in the room. This style of interior is just right for the rich, long tonal scale portrait I like to make. The lighting can make the subjects stand out from the background and look three-dimensional. (**SUBJECT**—Dianne Frantz and her daughters, Lindsey and Elissa; **DATE**—1996; **CAMERA**—Mamiya RZ67; **FILM**—Fuji NPH, ISO 400; **LENS**—65mm)

The posing and lighting of most studio and outdoor portraits have, from the beginning of photography to the present time, been closely tied to the Victorian portrait painters and photographers. After all, it is difficult to sell portraits to people unless we make them look very attractive. I do not know of any better course a modern portrait photographer could take to perfect their posing and lighting skills than to study the Victorians. There are only so many ways of lighting and posing our subjects to make them look their best, and the Victorians discovered most of them.

My strategy is to use the perfected ideas of the early painters and photographers and put them in modern backgrounds and clothing. However, while I may start with an idea from the past, when my portrait is completed it would be difficult to tell where the original idea came from.

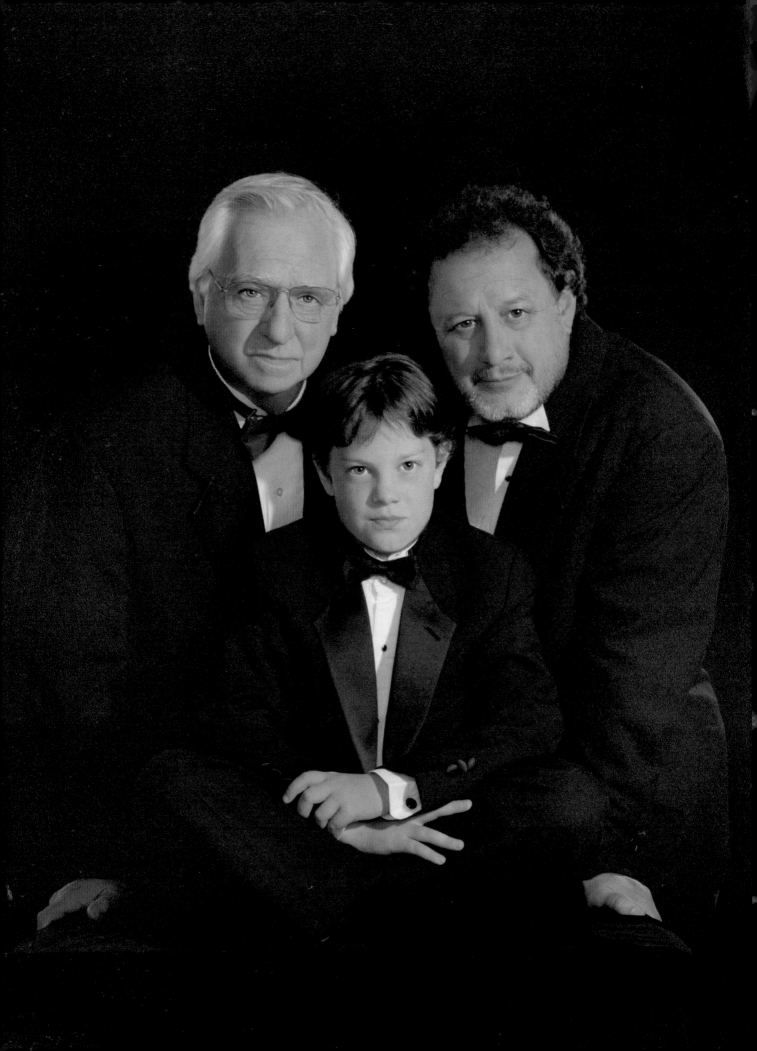

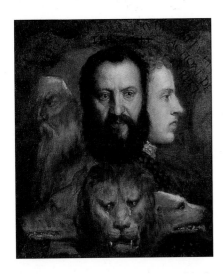

FACING PAGE—This portrait features three generations of the Brickell family. The grandfather, Edward Brickell, PhD., has worked for 50 years in education. Ed and I met when he was a teacher and I had just started in the business of photographing high schools. With him are his son, Sean Brickell (Public Relations, College of Fellows), and his grandson, Quinton Brickell, who is a black belt in karate. After viewing *An Allegory of Prudence* by Titian, in the National Gallery in London, I thought it would be a good idea for this portrait. I used four strobes. The main light and two skim lights were 7-inch reflectors; the fill light was a 48-inch umbrella. (**SUBJECT**—The Brickell family; **DATE**—2003; **CAMERA**—Toyo 4x5-inch; **FILM**—Fuji NPH, ISO 160; **LENS**—210mm)

LEFT—*An Allegory of Prudence* by Titian.

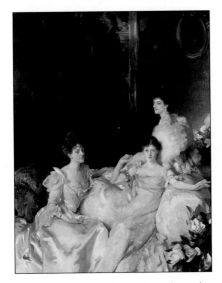

ABOVE—*The Wyndham Sisters* by John Singer Sargent.

RIGHT—I've always admired the painting *The Wyndham Sisters* by John Singer Sargent that hangs at the top of the stairs in the American Gallery of the Metropolitan Museum. I was in the lobby in the Adolphus Hotel in Dallas some years ago, and I knew this was the perfect background for a portrait of my daughters. I proposed a complimentary portrait for the hotel manager for its use. He

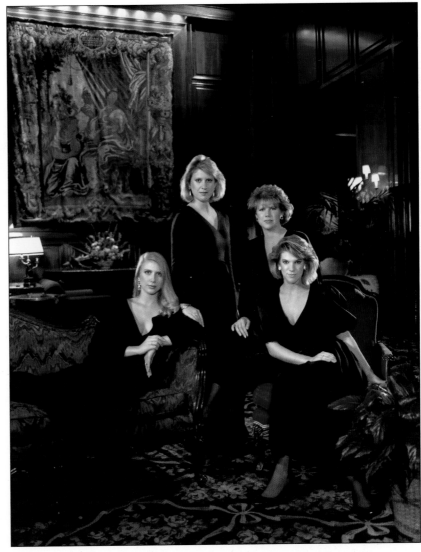

agreed and roped off the space for the portrait. Four tungsten lights were used: two mini-spots at 250 watts each and two 20-inch diffused reflectors with 1000-watt bulbs. The background was lit by the hotel's ambient light. (**SUBJECT**—The McIntosh sisters; **DATE**—1985; **CAMERA**—Mamiya RZ67; **FILM**—Kodak Type L, ISO 100; **LENS**—65mm)

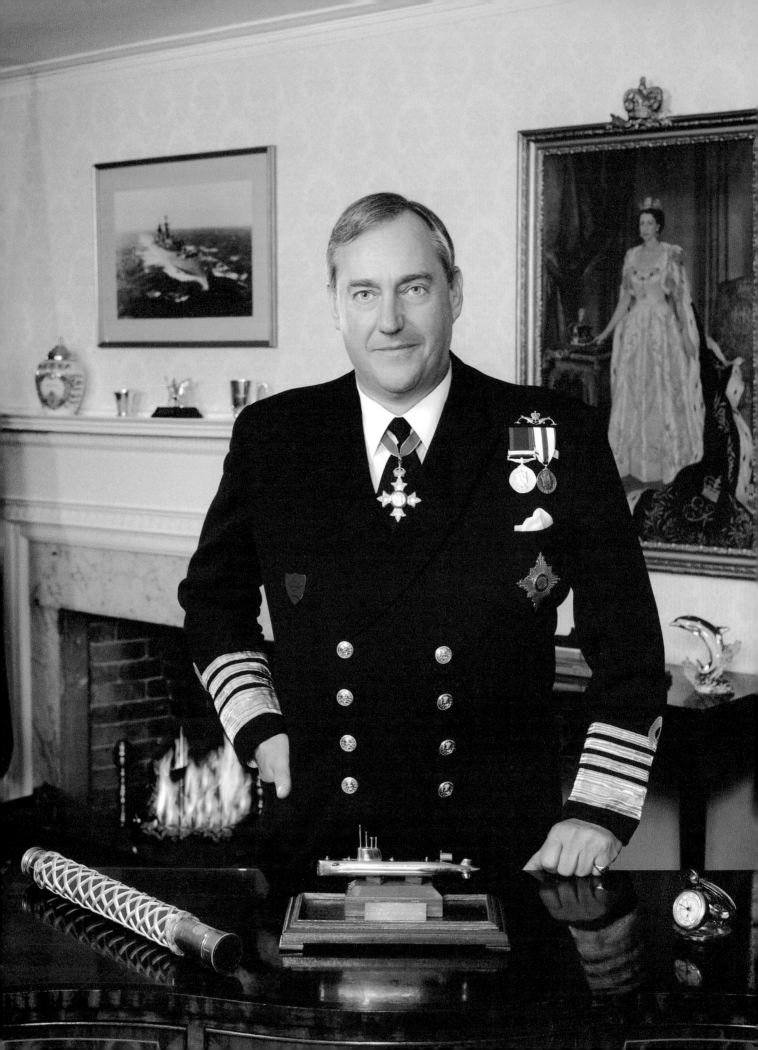

FACING PAGE—Admiral Perowne was photographed as the Deputy Supreme Allied Commander, Atlantic, for an exhibit of senior military leaders. The concept of the portrait came from seeing a portrait by John Singer Sargent called *Sir Frank Swettenham* in London's National Gallery. I like the confidant pose with the hand on the hip. The portrait of Admiral Perowne could have been painted in 1900. It is classic and timeless. Four strobes were used, and the exposure was made at ⅛ second to enhance the fire in the fireplace. (**SUBJECT**—Admiral Sir James F. Perowne, United Kingdom Navy; **DATE**—2001; **CAMERA**—Mamiya RZ67; **FILM**—Fuji NPS, ISO 160; **LENS**—65mm)

LEFT—*Sir Frank Swettenham* by John Singer Sargent.

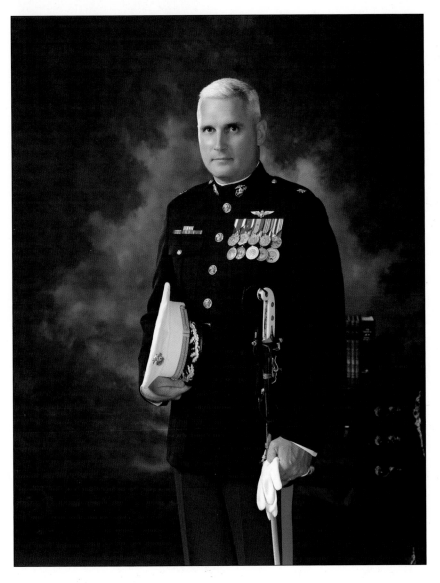

ABOVE—*Edouard Andre* by Franz Xaver Winterhalter.

LEFT—This portrait was inspired by *Edouard Andre*, a portrait of a French army officer painted in 1857 by Franz Xaver Winterhalter. (**SUBJECT**—Lt. Col. Michael Richards, United States Marine Corps; **DATE**—2003; **CAMERA**—Toyo 4x5-inch; **FILM**—Fuji NPS, ISO 160; **LENS**—Schneider f-5.6, 210mm)

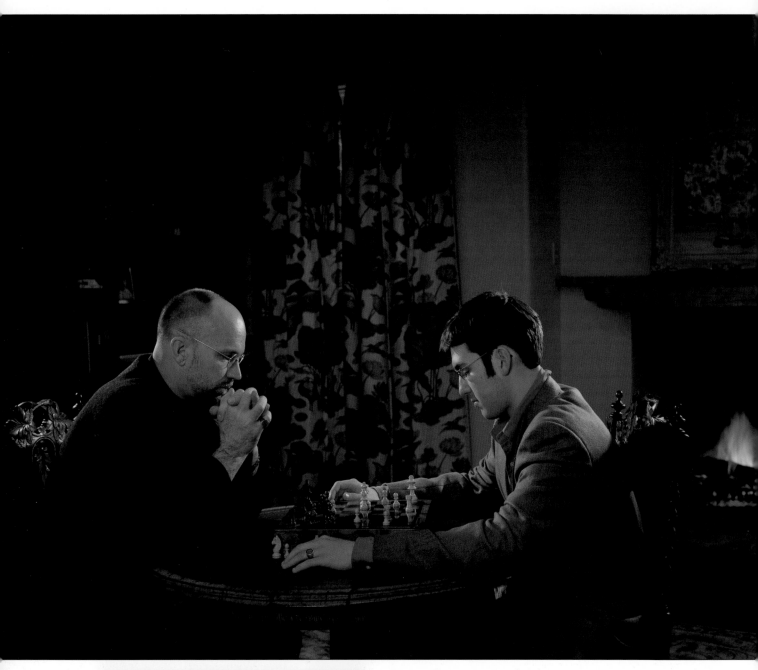

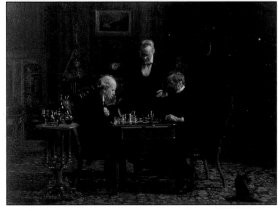

ABOVE—The inspiration for this portrait was *The Chess Players* by Thomas Eakins. This painting is in the Metropolitan Museum of Art. When I see a portrait painting I like in a museum, I buy a postcard or book of the artist's work for future reference. (**SUBJECTS**—Doctor Erick C. Eckman and his son Alex; **DATE**—2001; **CAMERA**—Mamiya RZ67; **FILM**—Fuji NPS, ISO 160; **LENS**—65mm)

LEFT—*The Chess Players* by Thomas Eakins.

ABOVE—*Ellen Terry* by George Frederick Watts.

RIGHT—The inspiration for this portrait came from a painting I viewed at the National Portrait Gallery in London. It was by George Fredrick Watts (1817–1908), of his 16-year-old wife, the future actress Ellen Terry. I made a portrait of my subject that closely resembled the painting, but it did not turn out the way I envisioned, so I began to innovate and changed the pose. (**SUBJECT**—model; **DATE**—1998; **CAMERA**—Mamiya RB67; **FILM**—Fuji NPS, ISO 160; **LENS**—150mm soft focus)

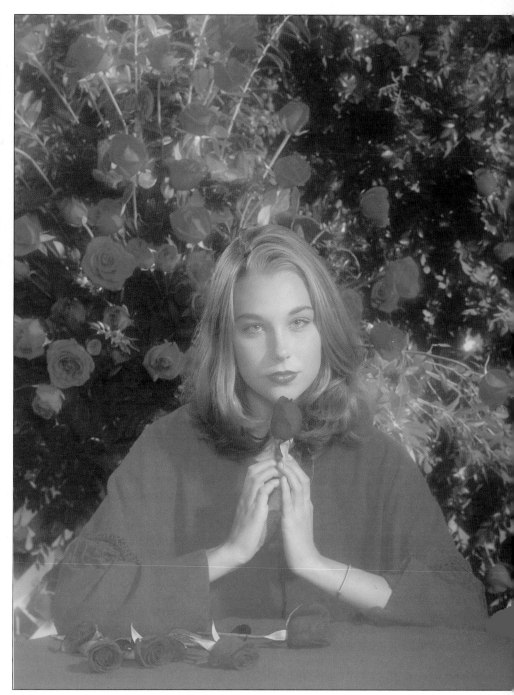

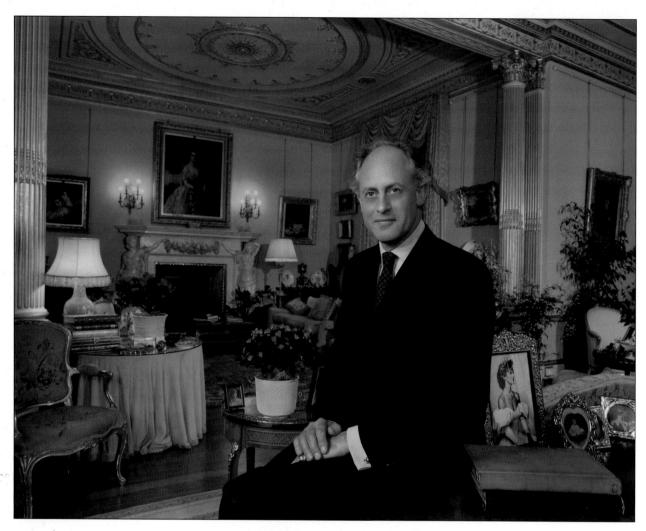

ABOVE—The Somerley Country Estate, home of the Earl of Normanton, was photographed to show its beautiful rooms which are available for special conferences. Somerley predates the Victorian era, but its furnishings fit very well in the Victorian style. Five strobes were used, two with 31-inch umbrellas and three with 7-inch reflectors and barn doors. The exposure was made at f-16 and $\frac{1}{15}$ second. (**SUBJECT**—The Earl of Normanton; **DATE**—1991; **CAMERA**—Mamiya RZ67; **FILM**— Fuji NPH, ISO 400; **LENS**—65mm)

FACING PAGE—Lori Bateman is a friend and model I have photographed a number of times. This portrait was planned a year before it was made. Just before it closed for the winter, I visited MacKay National Park, located 90 minutes from my home on the border between Virginia and North Carolina. I was impressed with the location and arranged the sitting for the following year at the same time. I will go to almost any length to get a fine portrait—I'll rent or borrow the clothes, buy the basket and flowers, and spend a half-day or more on the session. Most of my work is on canvas, made for the wall and framed in museum-quality frames. Here, I used a small ladder to get an elevated view. In this large, open area, the natural light from a weak sunset meant there was no need for any artificial light. The exposure was made at f-11 and $\frac{1}{15}$ second. (**SUBJECT**—Lori Bateman; **DATE**—1998; **CAMERA**—Mamiya RZ67; **FILM**— Fuji NPH, ISO 400; **LENS**—110mm)

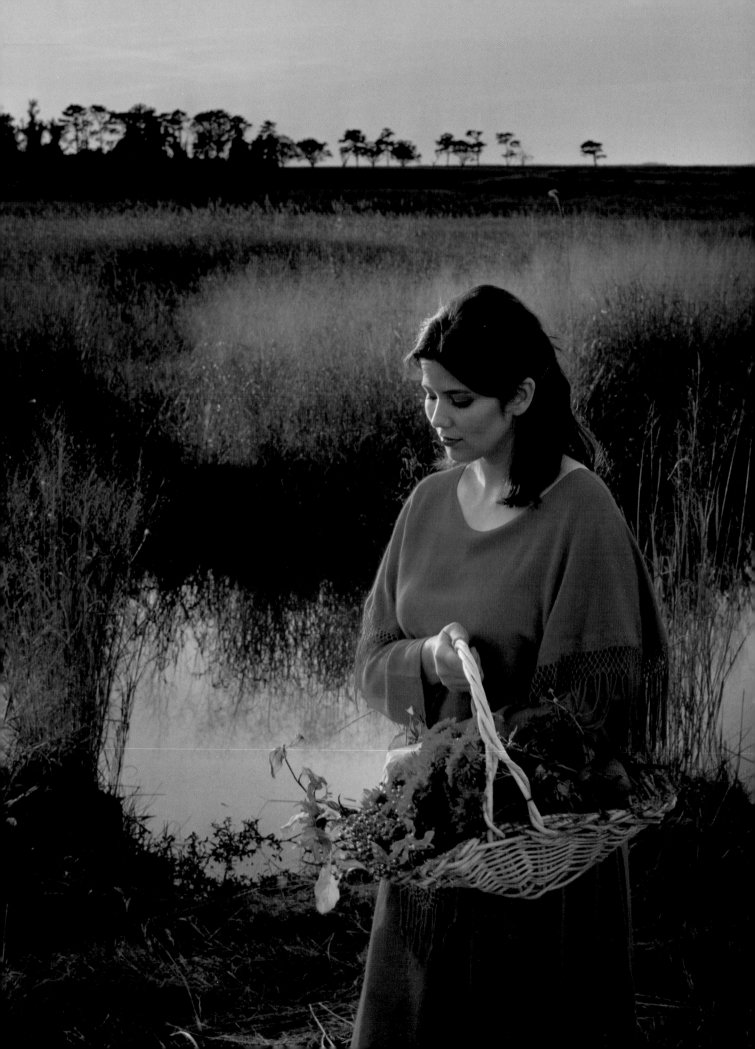

CHAPTER FIVE

PHOTOGRAPHING THE PHOTOGRAPHERS (1984–1989)

In 1948, I had just began my career in photography. My business at that time consisted of photographing high-school groups and sports for yearbooks, weddings on weekends, and babies for a penny a pound every Tuesday in department stores.

During this same time frame, Yousuf Karsh was world famous, having photographed the allied military and political leaders of World War II. Arnold Newman was a world-renowned magazine photographer; Cornell Capa was a photojournalist for *Mangum*. Linda Lapp was one year old. Ralph Gibson was only a little older, and Pete Turner was in high school.

Some thirty-six years later, in my spare time I began photographing the great photographers of the country as a self-assigned project. The International Photography Hall of Fame heard of my work and agreed to exhibit it in their museum in Oklahoma City, OK. This added a deadline and about twenty photographers I needed to photograph in one year for the exhibit.

My specialty in photography today is photographing executives, such as the CEOs and officers of major corporations. I suspected that it would be more

I photographed illustrative photographer Pete Turner in his studio in Carnegie Hall (New York City). Things got off to a great start when I photographed Pete. To break the ice, I told him that the pictures I was making of him looked so good, I would have to make a personal trip to the lab to guard the prints as they came off the processor—otherwise, the women in the lab would keep them as souvenirs. Pete replied, in mock seriousness, that he understood perfectly—he had that trouble all the time. (**SUBJECT**—Pete Turner; **DATE**—1984; **CAMERA**—Hasselblad; **FILM**—Kodak Vericolor, ISO 160; **LENS**—100mm)

Jay Maisel has been one of the country's top illustrative photographers for many years. When I was photographing him, he was seated with his ubiquitous cigar and looking a little too serious. I mentioned that I could not put his finished portrait in the window of my studio because it would be so strong, so powerful, and so dramatic that the women would probably break the window and steal it and my insurance would go up. Jay became less serious and I made my exposure. He asked if all portrait photographers used nonsensical humor to get different expressions from their subjects. He related that he had accompanied Arnold Newman on an assignment to photograph executives of a major corporation. He expected the conversation during the session to be serious, but Arnold used a lot of levity, humor, and body language to get the expressions he wanted. I told Jay that I believed a portrait photographer would use whatever degree of conversation or body language it took to get the best possible expression and pose to portray his or her subject the way they felt they should be portrayed. The exposure was made at f-16 and 1/15 second. (**SUBJECT**—Jay Maisel; **DATE**—1984; **CAMERA**—Hasselblad; **FILM**—Kodak Vericolor, ISO 160; **LENS**—50mm)

of a challenge to photograph photographers—people who know as much (or more) about photography as I do. As it happened, my apprehension was unfounded. The experience was great fun and one of the most satisfying projects of my career. Plus, I made some life-long friends.

The Portraits

The method I followed for photographing most of the photographers was to light the background separately, as if I were going to photograph the room. Then I would place the photographer in the foreground and light him or her separately with another set of lights. With the use of wide-angle lenses I was able to get a lot of space behind the subjects. I would then fill the space with artifacts and other items of interest to the subject. I usually spent about one hour with an assistant getting ready for the session.

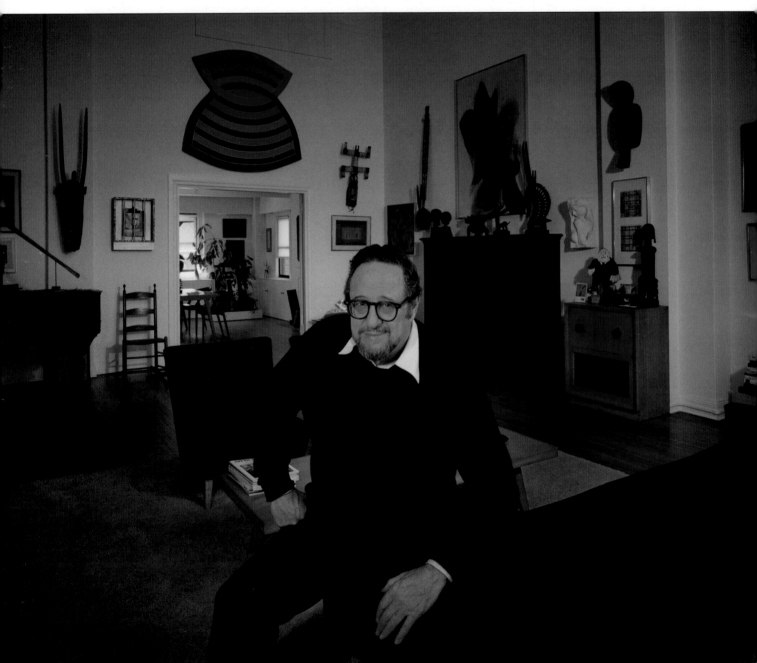

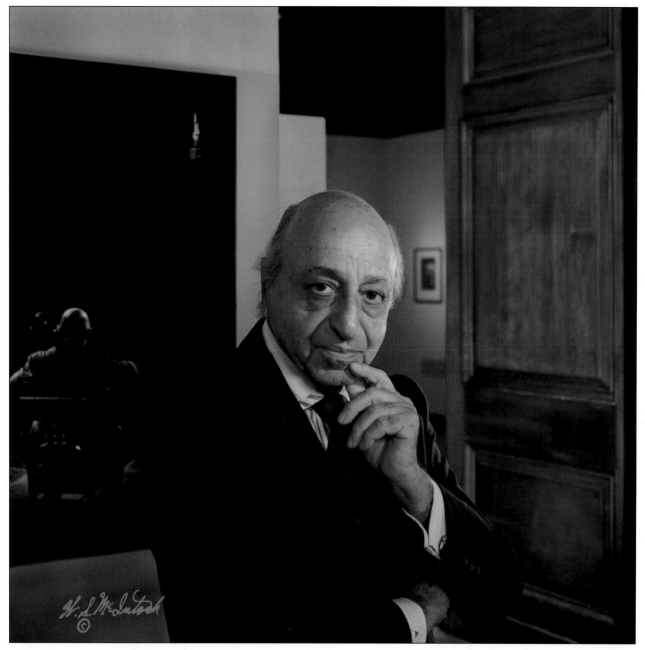

ABOVE—Yousuf Karsh has made classic portraits of more world-class leaders in every field than any photographer that ever lived. We met at the International Center of Photography in New York City for the portrait session. We talked about the history of photography for a while, and I noticed a characteristic pose with his hand on his chin as he spoke. To get him to be a little less serious, I mentioned that after his image passed through the lens of this camera, I was going to have it bronze-plated and have his name engraved on it, and it would be on display under his portrait in the Photography Hall of Fame. With his hand still on his chin, he nodded with a little knowing smile and said it was a very good idea. We used his portrait of Pablo Casals as a background. (**SUBJECT**—Yousuf Karsh; **DATE**—1984; **CAMERA**—Hasselblad; **FILM**—Kodak Vericolor, ISO 160; **LENS**—60mm)

FACING PAGE—When photographing Arnold Newman, I mentioned that I was recycling all the techniques I had learned by viewing his work over the last 36 years, and was going to use them to make his portrait. He smiled and replied that he would take no responsibility for the result. In my opinion, Arnold's creativity in placing subjects in their environment has never been supassed. His influence on my work, and the work of many other photographers, is obvious. (**SUBJECT**—Arnold Newman; **DATE**—1984; **CAMERA**—Hasselblad; **FILM**—Kodak Vericolor, ISO 160; **LENS**—Superwide 38mm)

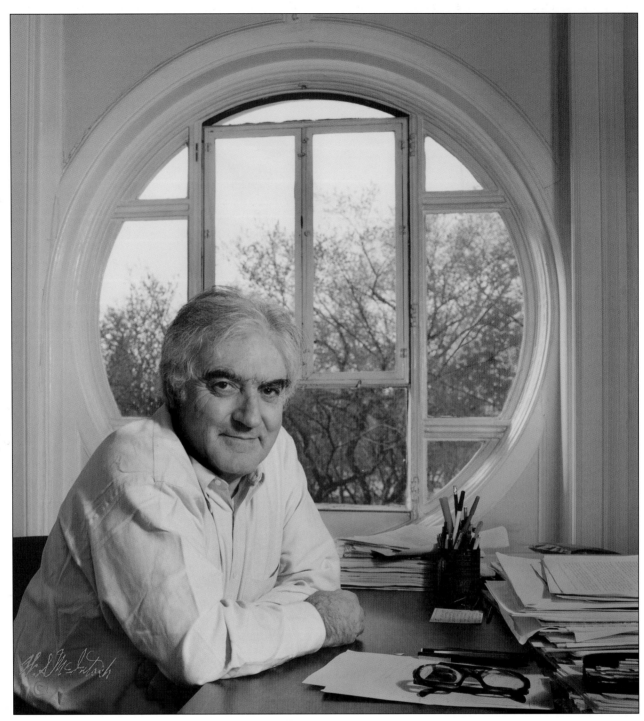

Cornell Capa was the director and founder of the International Center of Photography in New York City. He was in his spacious office on the third floor when I arrived. After viewing my work, he stated that he preferred a more informal approach for his portrait. He brought my attention to a beautiful round window right beside his desk, which overlooked Central Park. He returned to his desk and continued to work, as I spent about 30 minutes setting up my lights and making the necessary Polaroid tests. Throughout this procedure he would occasionally look up and make some droll comment about how slow I was compared to a photojournalist. When I began making exposures of Cornell, there was no problem getting a good expression. We had been joking all along, and his wit was much quicker than mine. Framing Cornell inside the round window, I thought, gave a unique look to a unique personality. (**SUBJECT**—Cornell Capa; **DATE**— 1984; **CAMERA**—Hasselblad 500CM; **FILM**—Kodak Vericolor, ISO 160; **LENS**—60mm)

Alfred Eisenstaedt's brilliant career as a photojournalist lasted over 60 years, mostly with *Life* magazine. I photographed Essie (as he was called around the *Life* magazine office) in a part of his office where he kept some photographs of his famous subjects. We talked about lighting techniques, and he was interested in my multiple strobes and how I got the light around him to light the background. With a 50mm lens on my Hasselblad camera, I moved him close to the camera so I was able to get light behind him. (**SUBJECT**—Alfred Eisenstaedt; **DATE**—1984; **CAMERA**—Hasselblad 500CM; **FILM**—Kodak Vericolor, ISO 160; **LENS**—50mm)

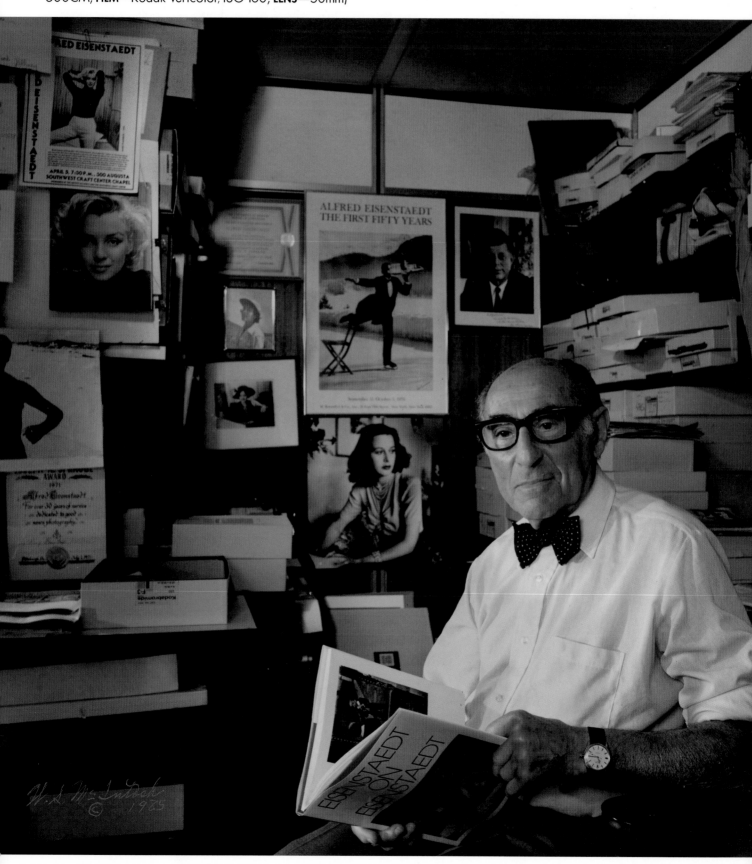

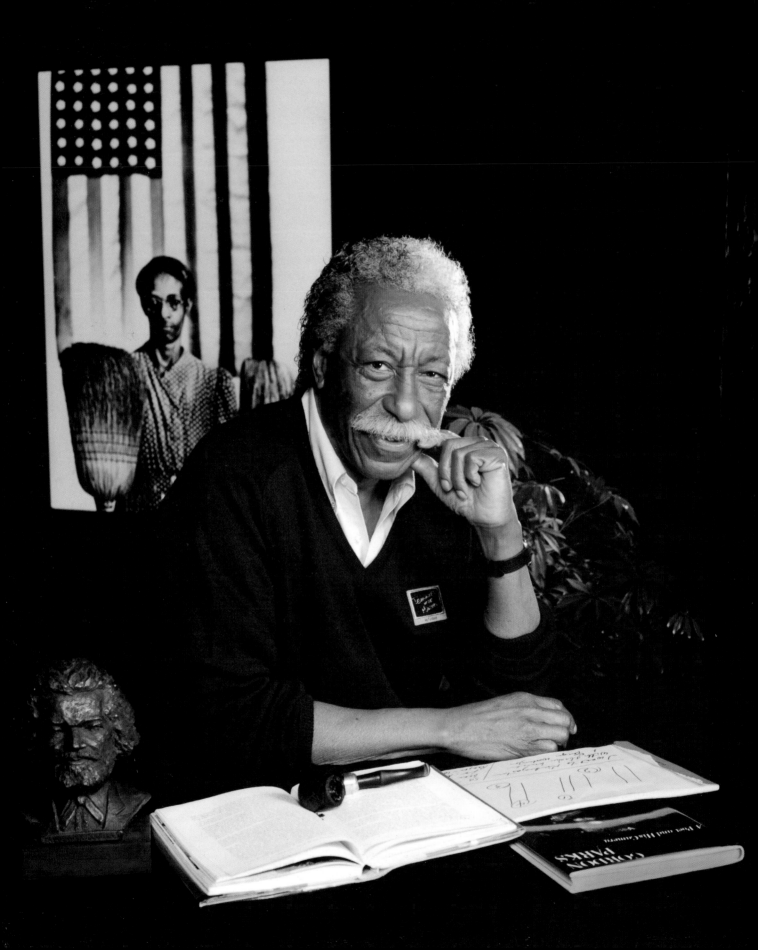

FACING PAGE—Gordon Parks, a photojournalist, author, and movie director, could be called a modern Renaissance man. Gordon and I were selected to be featured on a TV special titled *The Technique of the Masters* for The Learning Channel. The series ran in 1989 and was sponsored by the Eastman Kodak Company. Each of us did a biographical interview, showing our work, telling how we got started and what projects we were currently working on. I photographed Gordon

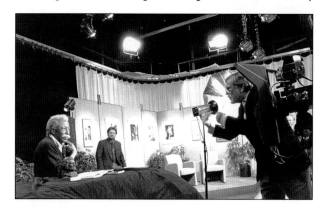

on the television set to show the viewers how I set up to make a storytelling portrait. Gordon brought some personal artifacts and several of his photographs. He picked the one he thought best represented his work. He has a great sense of humor and we had a good time. (**SUBJECT**—Gordon Parks; **DATE**—1989; **CAMERA**—Hasselblad 500CM; **FILM**—Kodak Vericolor, ISO 160; **LENS**—150mm)

LEFT—Here I am photographing Gordon on the television set for *The Technique of the Masters* program.

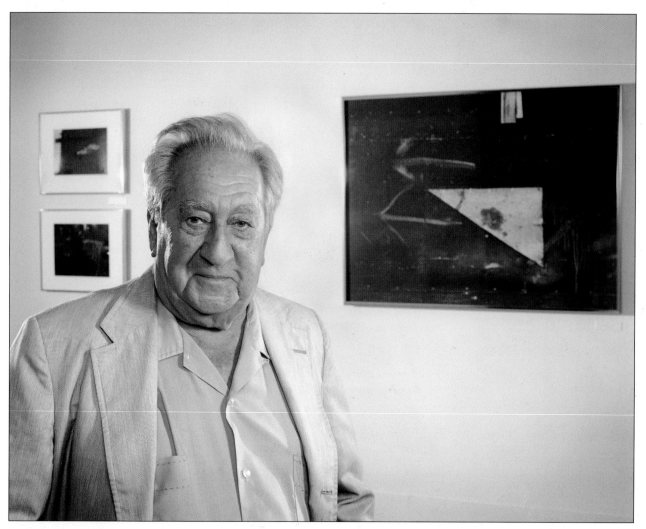

ABOVE—I photographed art photographer Aaron Siskind in the Dallas Museum of Art, where he had a major exhibition of his work on display. Aaron had a great sense of humor and a personality that sparkled. He was in his mid-eighties at the time and mentioned that he was going dancing after the exhibit reception was over. Five strobes were used. The fill light was a 31-inch umbrella placed behind the camera. The rest of the lights were 7-inch silver reflectors with barn doors—one main light (45 degrees to the right of the camera), two skim lights (135 degrees to his right and left rear), and one background light (from the left rear). (**SUBJECT**—Aaron Siskind; **DATE**—1987; **CAMERA**—Hasselblad; **FILM**—Kodak Vericolor, ISO 160; **LENS**—60mm)

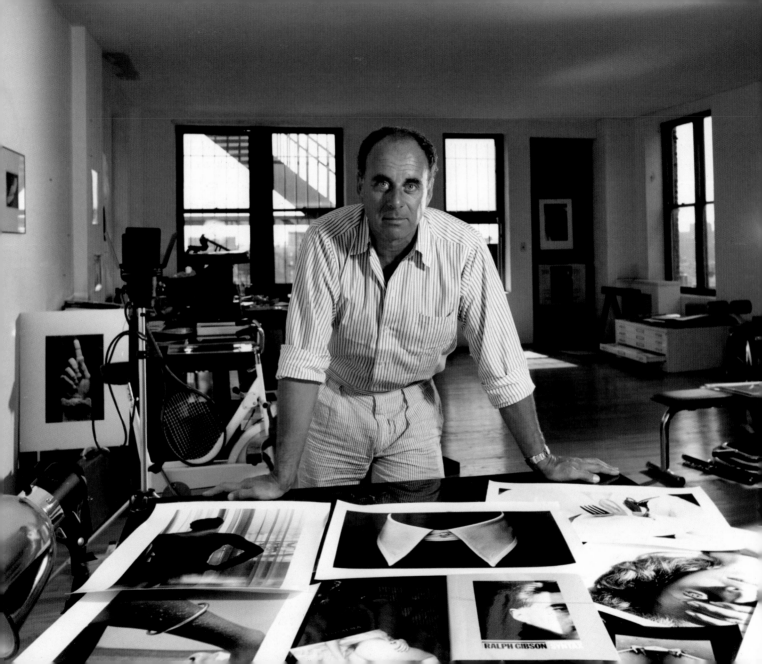

FACING PAGE—Ralph Gibson is an international art photographer and publisher of art photography books. His loft on Broadway in downtown New York City was very spacious and contained all the paraphernalia I would ever need to include in his portrait. It took longer to decide what to put in the image than it took to make the portrait. (**SUBJECT**—Ralph Gibson; **DATE**—1984; **CAMERA**—Hasselblad CM; **FILM**—Kodak Vericolor, ISO 160; **LENS**—50mm)

BELOW—Linda Lapp specializes in photographing children and family groups outdoors in the Portland, Oregon, area and also lectures to photographers throughout the U.S. Since Linda photographs little people, she frequently lays on her stomach to get down on their level. I thought it proper to photograph her this way, so we sought a proper background to give this effect. It so happened that this background was by the side of a road and the only position for me was to lie very uncomfortably in a ditch full of briers—with my feet in the water. I was below her looking up through the bushes with my camera. Very little humor was needed on my part; my position was funny enough. (**SUBJECT**—Linda Lapp; **DATE**—1984; **CAMERA**—Hasselblad CM; **FILM**—Kodak Vericolor, ISO 160; **LENS**—60mm)

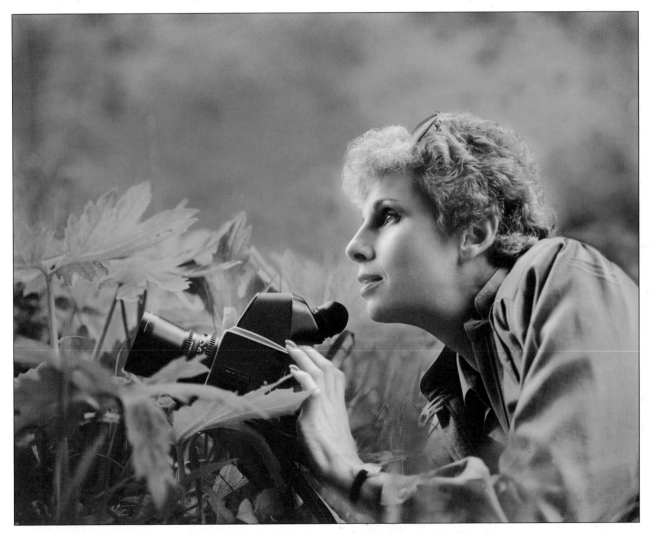

CHAPTER SIX
THE TWILIGHT PORTRAIT

The best time to make outdoor portraits is just before the sun comes up and just before the sun goes down, especially on bright, sunny days. I live close to the Atlantic Ocean, so most of my outdoor portraits are made in the sand dunes or on the oceanfront. The same technique would also apply in wide open spaces without trees or shade. It is possible to make portraits during normal daylight hours in these conditions, but I find that most subjects squint a little because of the bright sun. I also find the light to be very contrasty, resulting in very dark shadows.

For these images, I used a bare bulb Lumedyne strobe, which covers a wider angle for groups and gives a softer light. The standard 5-inch reflector concentrates the light and will leave a harsh, dark shadow unless it is used very close to the camera position. It is also more directional and would not have covered the groups evenly from side to side if it was placed close to the subjects.

This portrait was made just after the sun went down. A Lumedyne bare bulb strobe was directed on the group and placed close to the camera position. The sky had very nice clouds, but I wanted them to be a little more dramatic. The ambient light exposure measured f-8 at $\frac{1}{30}$ second, so I set the strobe at f-8 and exposed at f-8 at $\frac{1}{60}$ second to underexpose the sky one stop and make it more dramatic. (**SUBJECT**—Dr. and Mrs. Anthony G. Velo and family; **DATE**—2000; **CAMERA**—Mamiya RZ67; **FILM**—Fuji NPZ, ISO 800; **LENS**—90mm)

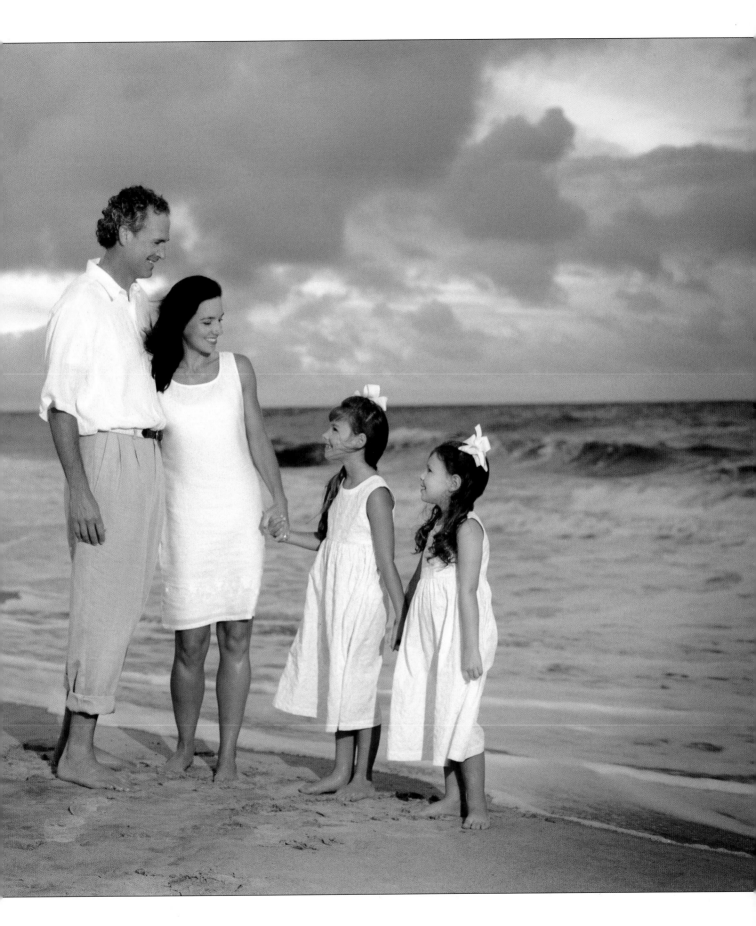

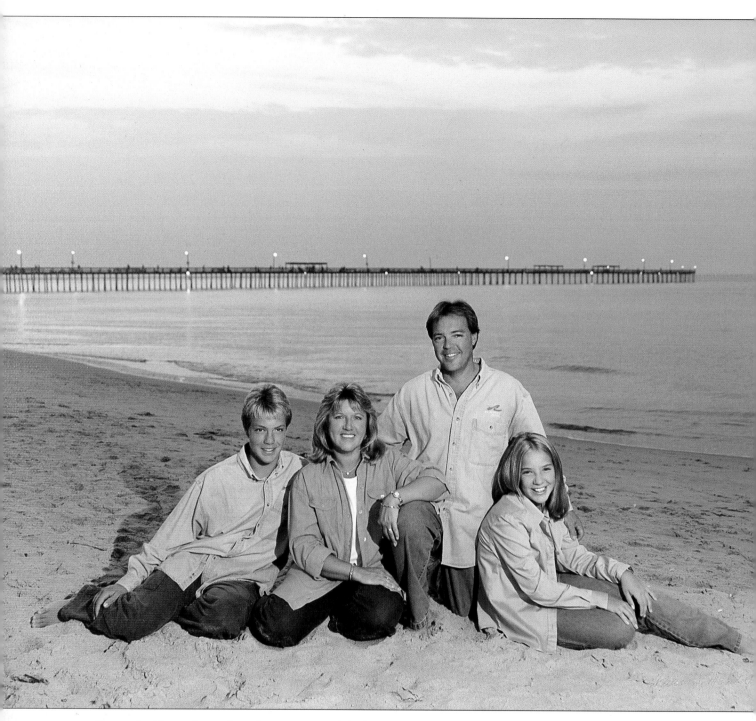

The sun had been down about five minutes and the light was diminishing. The ambient light exposure was ⅛ second at f-8. I set the strobe at f-8. Matching the ambient light with the strobe means that the strobe will yield about one stop more light on the subject. It will be similar to a studio lighting setup where the fill light is one stop less than the main light. A 65mm wide angle lens was used to get most of the lighted pier in the background. (**SUBJECT**—The Browning family (Terry Jr., Terry, Wanda, and Kasey); **DATE**—2000; **CAMERA**—Mamiya RZ67; **FILM**—Fuji NPZ, ISO 800; **LENS**—65mm)

The sun had gone down and the sky was beautiful. The ambient light exposure was f-8 at $\frac{1}{15}$ second. I set the strobe for f-8 and the shutter speed at $\frac{1}{30}$ second to make the sky a little deeper and more dramatic. (**SUBJECT**—Nicole and Scott Schuett with daughter Cameron; **DATE**—2003; **CAMERA**—Mamiya 645AFd; **FILM**—Fuji NPZ, ISO 800; **LENS**—55–110mm zoom)

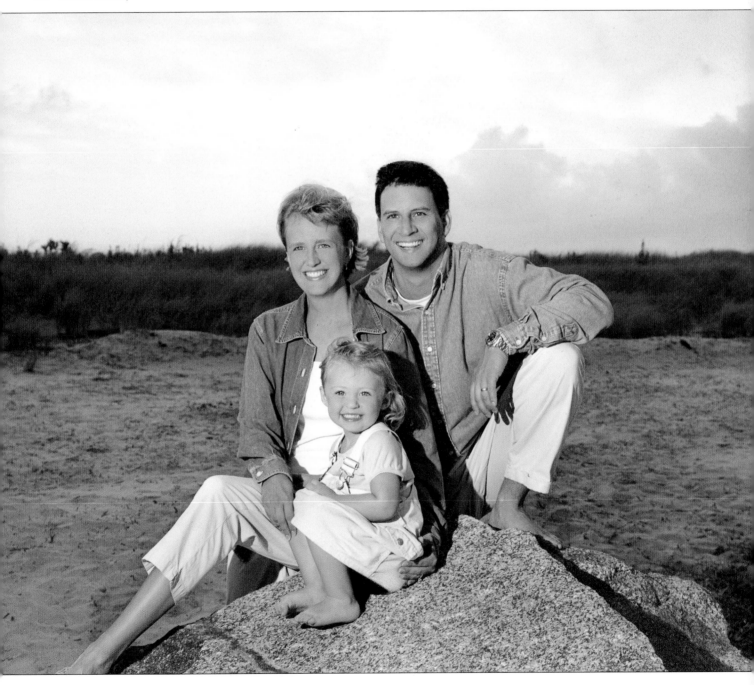

This sunrise portrait was made just after the sun came up. The ambient light was f-8 at $\frac{1}{30}$ second. The strobe was set for f-8, and I set the shutter speed to $\frac{1}{60}$ second to make the sun more dramatic. There is no shadow detail on the faces, but it is not needed, because the strobe was just a little to the left of the camera. (**SUBJECT**—Engagement portrait of Christopher Cook and Elizabeth Costigan; **DATE**—2003; **CAMERA**—Mamiya 645AFd; **FILM**—Fuji NPZ, ISO 800; **LENS**—55–110mm zoom)

The sun had been down about fifteen minutes. The ambient light was $\frac{1}{2}$ second at f-4.5, I exposed at $\frac{1}{4}$ second at f-4.5. This made the sky about one stop underexposed. I try not to expose portraits with children at $\frac{1}{2}$ or 1 second; although the strobe will stop any movement, there can still be a slight ghost image around anyone who moves. (**SUBJECT**—The Nate Green family; **CAMERA**—Mamiya RZ67; **FILM**—Fuji NPZ, ISO 800; **LENS**—65mm)

FACING PAGE—When I saw this '65 Mustang in front of a clothing store, I went in looking for the owner and met John, who was being fitted for clothes. He liked the idea of having me photograph him, Judy, and the beautifully restored car. He and Judy selected clothes and a straw hat to go with the handsome retro car. The sun had been down about ten minutes when the light was just right. To get a better angle on the automobile, I used a ladder to elevate me about four feet. The 65mm lens was used to make the car look longer. The exposure was $\frac{1}{4}$ second at f-8. (**SUBJECT**—John and Judy Maragon; **DATE**—2001; **CAMERA**—Mamiya RZ67; **FILM**—Fuji NPZ, ISO 800; **LENS**—65mm)

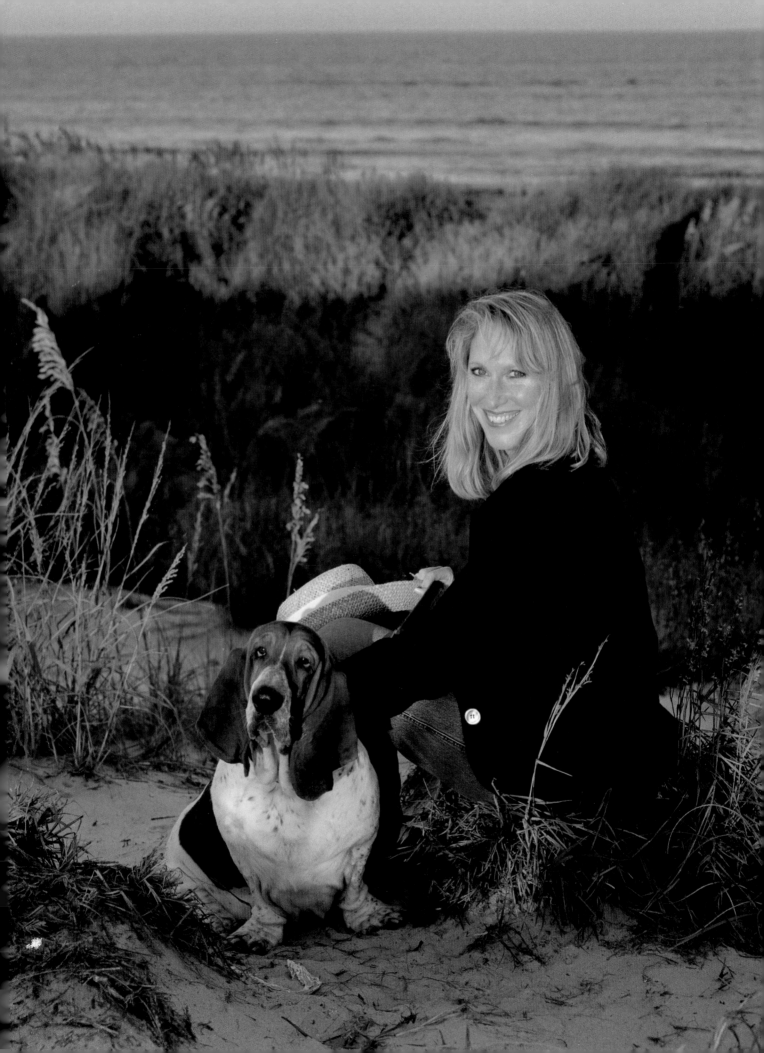

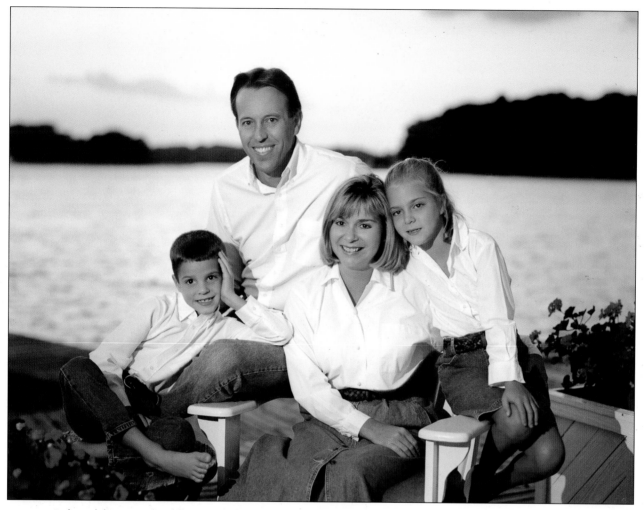

ABOVE—I placed the potted red flowers in the portrait to fill empty space and improve the design of the image. The fading sun was right behind Dad. The exposure was made just before it went below the horizon. The exposure was ⅟₁₅ second at f-5.6. (**SUBJECT**—The Robert Taylor family; **DATE**—1997; **CAMERA**—Mamiya RZ67; **FILM**—Fuji NPH, ISO 400; **LENS**—65mm)

FACING PAGE—A good-looking young woman and her dog are always a good picture combination. The sun on the beach was just right when this portrait was made. A strobe was not needed; the sun was just a little to the subject's left. The exposure was ⅟₃₀ second at f-5-6. (**SUBJECT**—Michelle Lyons; **DATE**—1997; **CAMERA**—Mamiya RZ67; **FILM**—Fuji NPH, ISO 400; **LENS**—65mm)

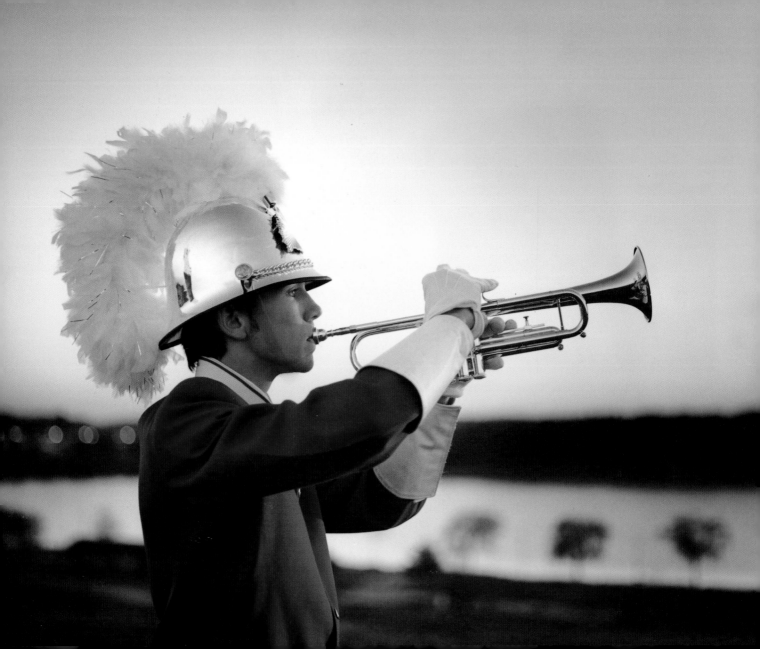

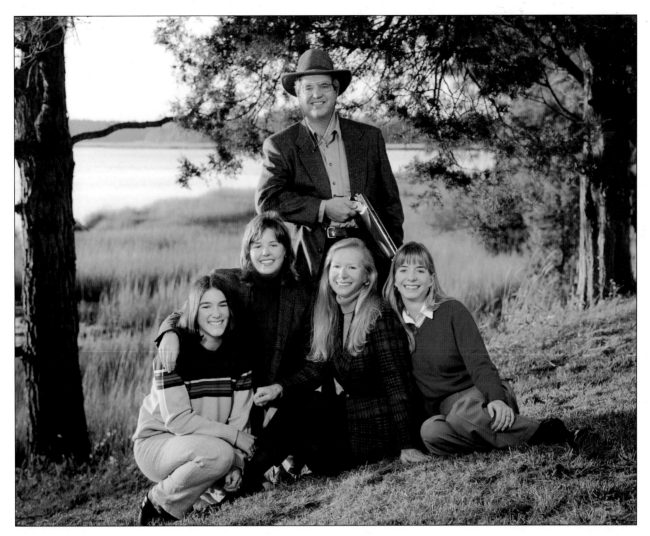

FACING PAGE—I had visited the top of this hill at sunset and knew it would make a great background for the right subject. A friend recommended that I photograph this young man in his stunning band uniform. I wanted a clear background, so the hill at sunset was just right. The portrait was made in the fall, so the sunset did not last very long. I had about a five-minute window to get the last rays of the sun lighting his face at its most dramatic. The exposure was ⅟₁₅ second at f-4. The strobe was set at its lowest power with a double handkerchief over the bare bulb. I wanted just enough strobe light to keep some detail in the shadows. The exposure was made at f-5.6 and ⅟₁₅ second. (**SUBJECT**—David Soroka, bugler; **DATE**—1997; **CAMERA**—Mamiya RZ67; **FILM**—Fuji NPS, ISO 160; **LENS**—110mm)

ABOVE—I traveled about two hours to photograph this family at their lake house. Whenever I can, I use the sun behind my subjects. It gives the portrait more depth and dimension and separates the subjects from the background. I like to use slanted ground to pose people on; it allows me to get more interesting asymmetrical poses. This portrait was made just before the sun went down. The exposure was f-8 at ⅟₃₀ second, with a bare-bulb strobe set for f-8. (**SUBJECT**—The Starer family; **DATE**—1995; **CAMERA**—Mamiya RZ67; **FILM**—Fuji NPH, ISO 400; **LENS**—65mm)

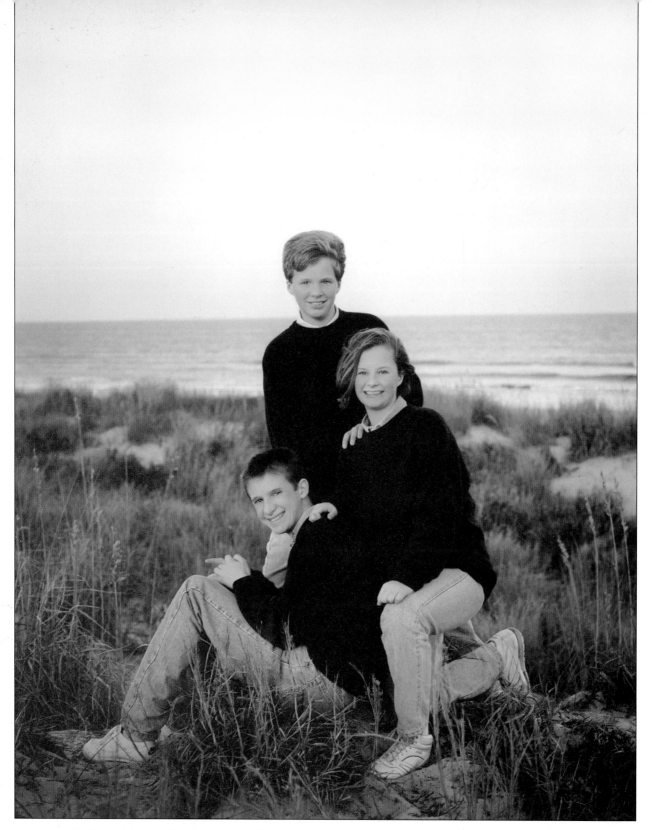

ABOVE—Mike (standing), Kathy (bottom right), and Paulie (bottom left) are my daughter Lisa's children (my grandchildren). This portrait was made using the last rays of the sun. The exposure was ⅟₁₅ second at f-11. (**SUBJECTS**—The Herbert family; **DATE**—1996; **CAMERA**—Mamiya RZ67; **FILM**—Fuji NPH, ISO 400; **LENS**—65mm)

FACING PAGE—I happened to meet up with Mark Spenser one late summer evening when I was roaming around looking for some scenery to photograph. He was standing on his dad's fishing boat. He looked just right, so I asked him to pose for me. I moved him a little for the right light, and made one of my very finest portraits of a young man. This portrait was made in 1970, so Mark is about 45 years old now. (**SUBJECT**—Mark Spenser; **DATE**—1970; **CAMERA**—Minolta 101; **FILM**—Kodachrome II, ISO 25; **LENS**—85mm, f-2)

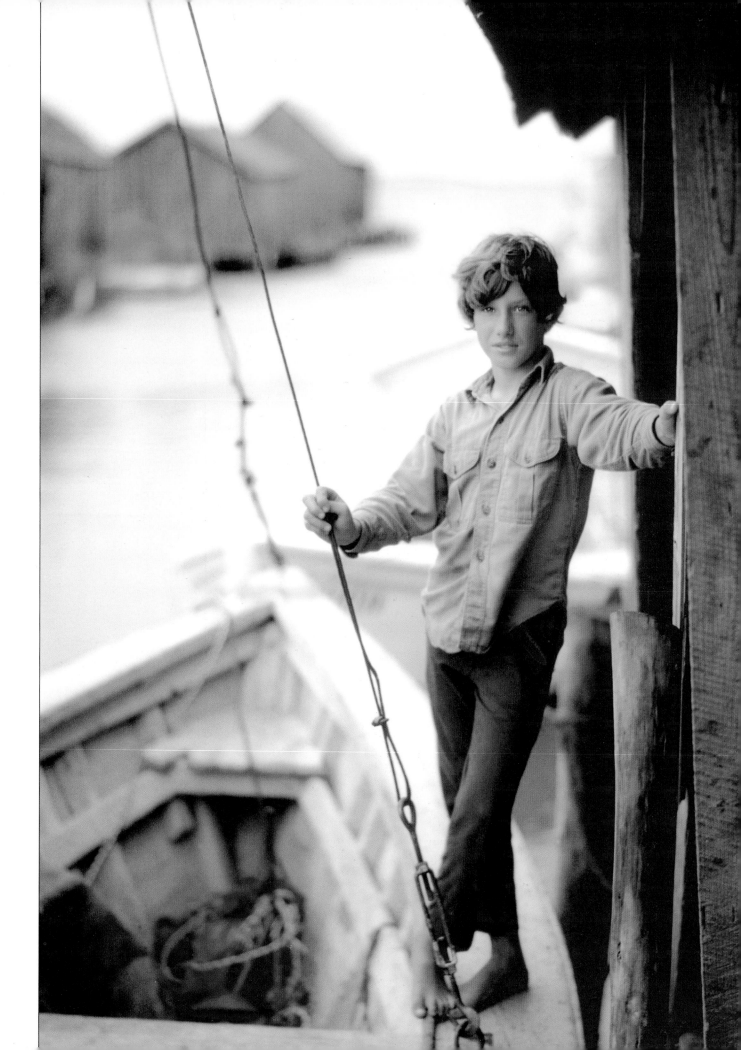

There can be no formula for this style of unstructured posing. The best ways to obtain a feeling of balance, a way to distribute the mass and weight of the subjects that will work within the space, can only be acquired through a lot of trial and error and experience. To analyze the design, divide the rectangular frame into thirds; you will notice the left third and the right third each have one child and horse of about the same weight and size. The maximum weight of the portrait is in the middle, and is still balanced by the combined total weight of the woman and the child against the total size and weight of the man. The portrait was made just before the sun went down and was framed through the barn door. The main light was the sun at the right rear, creating a strong back light that highlighted the left side of the group's faces. The fill light was the other side of the barn wall, which was painted white. (**TITLE**—*Back to the Stable*; **DATE**—1975; **CAMERA**—5x7-inch view camera; **FILM**—Kodak Vericolor II, ISO 160; **LENS**—250mm Imagon soft focus)

CHAPTER SEVEN
PEOPLE AT WORK

During my early years in photography, most portraits were made in the studio. Today with medium format cameras and efficient, portable monolight and battery-operated strobes, it is practical for photographers to go to most any location and make portraits. People like portraits that tell a story about their lifestyle or work. I have specialized in location portraiture for over twenty years and find it challenging, artistically satisfying, and a lot of fun.

Photographing people in all types of work and life situations requires a variety of portable strobes, cameras, lenses, ladders, tripods, and other photographic accessories.

I use the Mamiya RZ67 camera with the 37mm fisheye, 50mm, 65mm, 90mm, 140mm, RB 150mm soft focus, and 180mm lenses. I carry eight Calumet Travelite 750 monolights and two Lumedyne battery strobes.

I also use a Gitzo G1349 carbon tripod with the Gitzo G1378M ball-joint head (which will reach almost six feet), a Gitzo G525 tripod (which will reach about seven feet), and an old Davis & Sanford (which will reach to ten feet). I use the carbon tripod for my outdoor sittings, unless I need the height of the G525 or the Davis & Sanford. I have used the Gitzo tripods for over thirty years. My work takes me into the ocean surf, sand dunes, and just about anywhere you can imagine a portrait being made, so I need a tripod that will withstand a lot of heavy treatment.

The film I use, depending on the subject matter, is Fuji NPS 160, the new NPH 400,

FACING PAGE—Al Doumar's uncle invented the ice cream cone at the St. Louis Exposition in 1904. The Doumar name is a legend and has been in the restaurant business about 99 years now. I have known Al all my life and wanted to make a portrait to show him at work. Al arranged for three convertibles to come and pose for a night portrait at his drive-in restaurant in Norfolk, Virginia. Long extension cords were run from the restaurant to five strobes. The strobes I use on location, when battery strobes are not practical, are Calumet Travelite 750-watt monolights. The main light was a 31-inch umbrella placed 45 degrees to Al's left. The fill light was a similar strobe, back and a little to the left of the camera. A strobe with a 7-inch reflector and barn doors was placed about 90 degrees to the right, lighting the two people to Al's left, and a similar strobe was placed farther to the right, lighting the car behind them. The fifth strobe was placed at the far left rear to light the cars in front of Al. I had to use Fuji NPS 160 film because, at the time, it was the only film that would photograph fluorescent lights as the eye sees them, without a green tint. The exposure was made at f-11 and ¼ second. (SUBJECT—Al Doumar; DATE—1995; CAMERA—Mamiya RZ67; FILM—Fuji NPS, ISO 160; LENS—65mm)

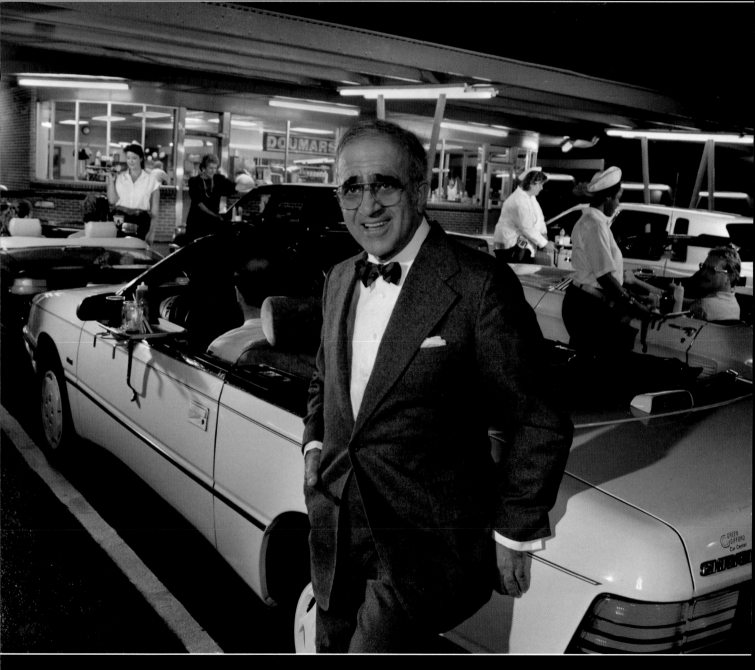

NPZ 800, and for black & white, Acros 100.

Some of my equipment is used only a few times a year, but if you get the right client, you can pay for it on one job. I equate photographic equipment with surgical tools. Imagine a doctor was removing your appendix and found a tumor in your stomach but couldn't remove it because he didn't have the right instrument at his disposal. In much the same way, a professional photographer needs to have professional equipment available to do whatever the photograph requires.

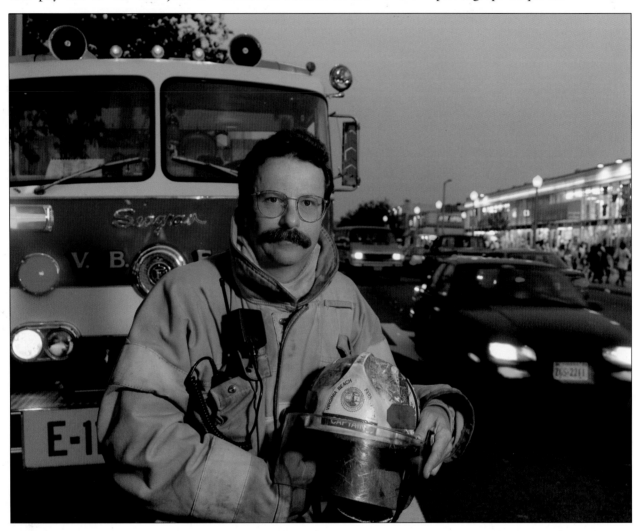

ABOVE—Captain Weinder was photographed on Atlantic Avenue at the resort center of Virginia Beach. We had to wait for the cars to come to almost a complete stop for this twilight portrait. I like the excitement of all the lights on the fire engine, stores, cars, and the people in the background. I used a Lumedyne strobe set for f-6.3 at ¹⁄₁₅ second. The ambient light metered f-6.3 at ¹⁄₁₅ second. (**SUBJECT**—Captain Gary Weinder, Virginia Beach Fire Department; **DATE**—1997; **CAMERA**—Mamiya RZ67; **FILM**—Fuji NHGII, ISO 800; **LENS**—65mm Mamiya Sekor)

FACING PAGE—The Silver Diner attracted me with its neon light display. I arranged with Keith and Alex to pose with a motorcycle in front at night. The lights illuminating the parking lot in front of the diner were the same intensity as the diner. It was necessary to place a 40x60-inch black cloth panel, stretched across plastic tubing and held up by two 12-foot light stands, to keep the light off the subjects. Their faces would have been overexposed with both the strobes and parking lot lights on the subjects. Two Lumedyne strobes lit the subjects, one slightly to the left of the camera with bare bulb, and the other with a 5-inch reflector placed 135 degrees to the left of the subjects in the background. The strobes were set for f-8. The exposure for the diner's lights and the strobes was f-8 at ¼ second. (**SUBJECTS**—The Silver Diner with Keith and Alex; **DATE**—2001; **CAMERA**—Mamiya RZ67; **FILM**—Fuji NPZ, ISO 800; **LENS**—50mm Mamiya Sekor)

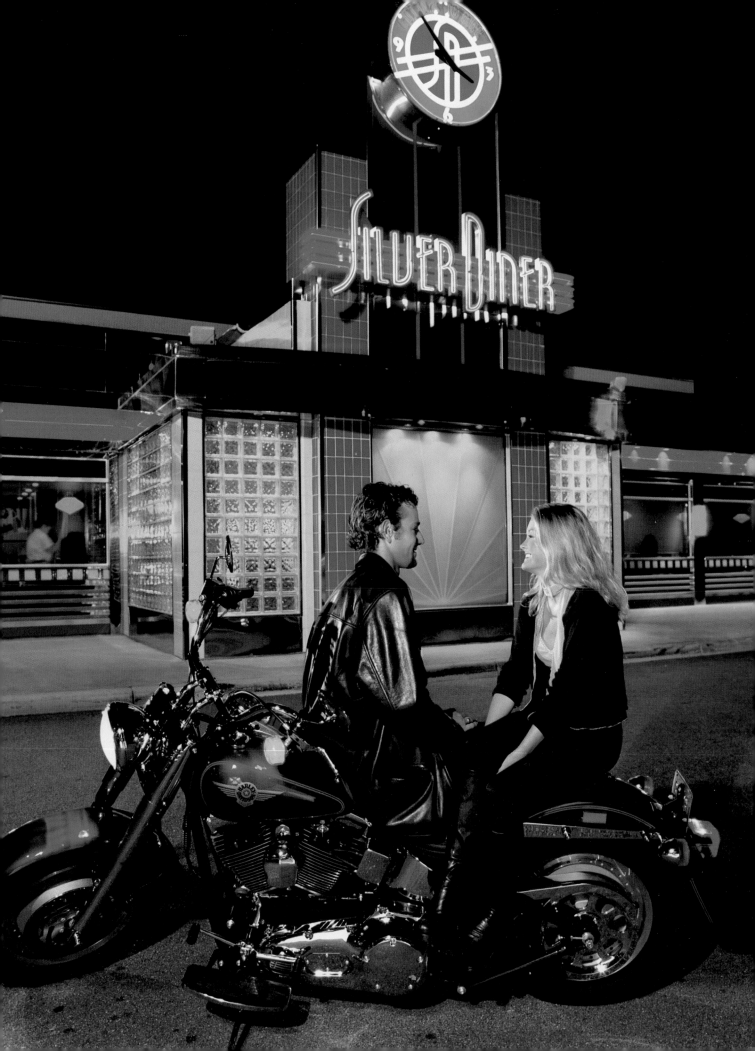

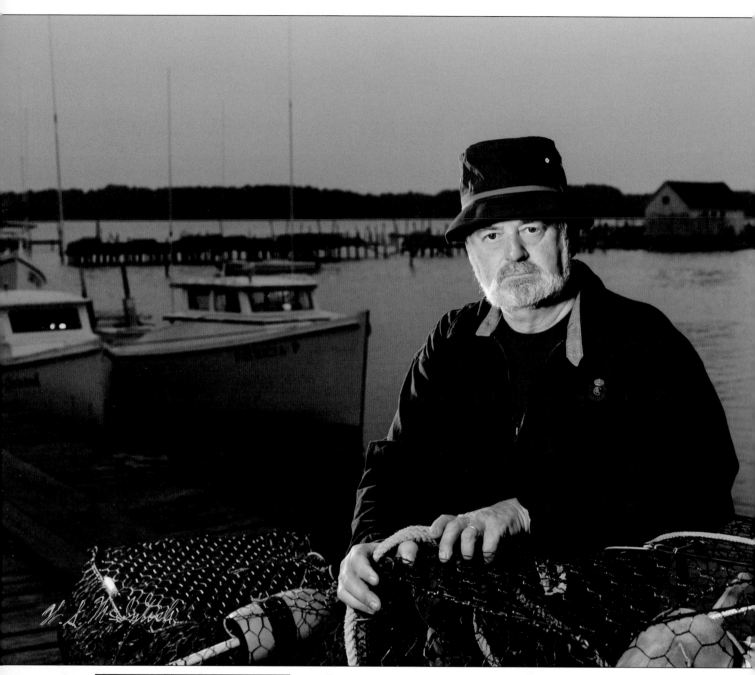

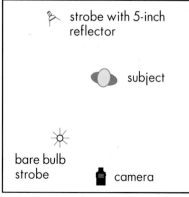

strobe with 5-inch reflector

subject

bare bulb strobe

camera

Willie paints marine and water scenes on the Eastern Shore of Virginia. I photographed him at twilight, backed by the type of scene he paints. We went to a hardware store and bought two big battery lights to put in the boats so they would have some life to them. The sun had been set for over fifteen minutes, so the ambient light was one second at f-4.5 on Fuji NPH 400. One bare-bulb strobe was placed 45 degrees to his left with a double handkerchief over it to subdue the light down to f-4.5. The other strobe was 135 degrees to his right rear, with a silver 5-inch reflector. It was far enough away that it did not have to be subdued. (**SUBJECT**—Willie Crockett, artist; **DATE**—1997; **CAMERA**—Mamiya RZ67; **FILM**—Fuji NHGII, ISO 800; **LENS**—65mm Mamiya Sekor)

Bill Thumel's 1965 AC Cobra is one of only 500 built and is valued at over $300,000. This Cobra is his favorite car. To photograph an automobile, I look for a background that will not detract from the car. The best background is an empty field, or the ocean, a wooded area, or the edge of a lake. This portrait was planned for the early twilight. The sun had not gone down yet, but it was close to the horizon. A 50mm wide-angle lens was used to exaggerate the length of the car. I was on a 6-foot ladder to get the best angle. (**SUBJECT**—Bill Thumel; **DATE**—1991; **CAMERA**—Mamiya RZ67; **FILM**—Fuji NGH, ISO 400; **LENS**—50mm)

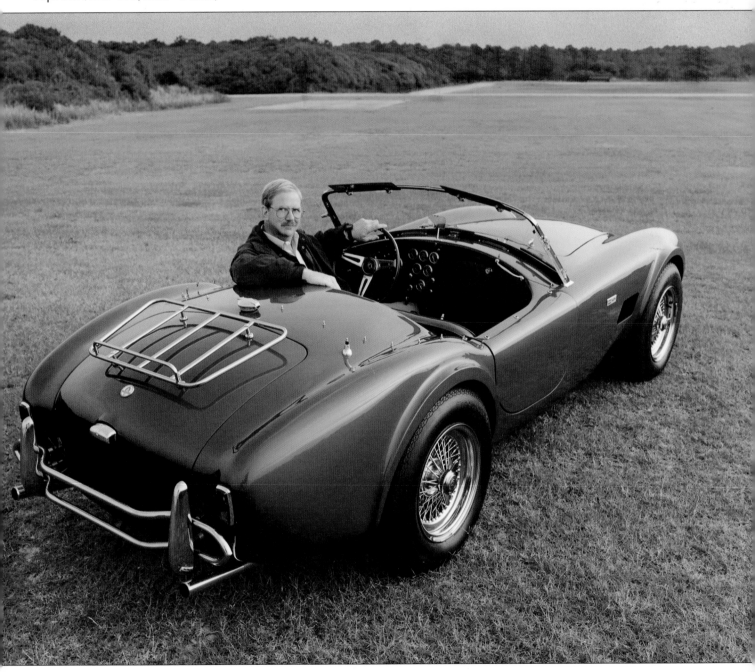

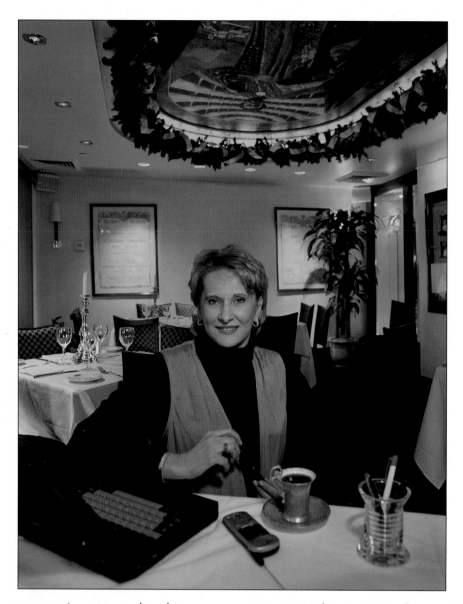

ABOVE—Janet is a media relations representative in Washington, D.C., who organizes large press parties for the top companies and political parties in Washington. She likes to do some of her writing in a private dining room of the posh restaurant Café Milano in Georgetown, where she holds many of her parties. This is the beautiful room I photographed her in, creating a portrait for *Home and Design Magazine*. As usual, the tables were moved to position my subject to her best advantage. The lighting was mostly the ambient light of the restaurant room. One strobe with a 31-inch umbrella was used high and right over the lens of the camera. The white tablecloth was the reflector fill. The four layers of the Fuji NPS 160 film compensated for the warm tungsten light very well. It is close to the way the room looked. (**SUBJECT**—Janet Stairhar, media relations representative; **DATE**—2000; **CAMERA**—Mamiya RZ67; **FILM**—Fuji NPS, ISO 160; **LENS**—50mm Mamiya Sekor)

FACING PAGE—Mr. Sadr and his wife and children own and operate a large oriental and tribal rug salon that is close to my studio. I approached Mr. Sadr with the idea of photographing him with one of his rugs as a background. He showed me a variety of his native Afghan clothes, and we picked a robe that matched one of his rugs. I photographed him in his rug salon with a 4x5-inch Toyo field camera and a 210mm Schneider f-5.6 lens. Five Travelite strobes were used: one 16-inch diffused reflector with barn doors as main light, one bounced off the white wall behind the camera as fill light, two with barn doors as skim lights (135 degrees to the left and right behind the subject), and one with barn doors lighting the rug background. (**SUBJECT**—Mr. Sadr; **DATE**—2000; **CAMERA**—4x5-inch Toyo field camera; **FILM**—Fuji NPS, ISO 160; **LENS**—Schneider f-5.6, 210mm)

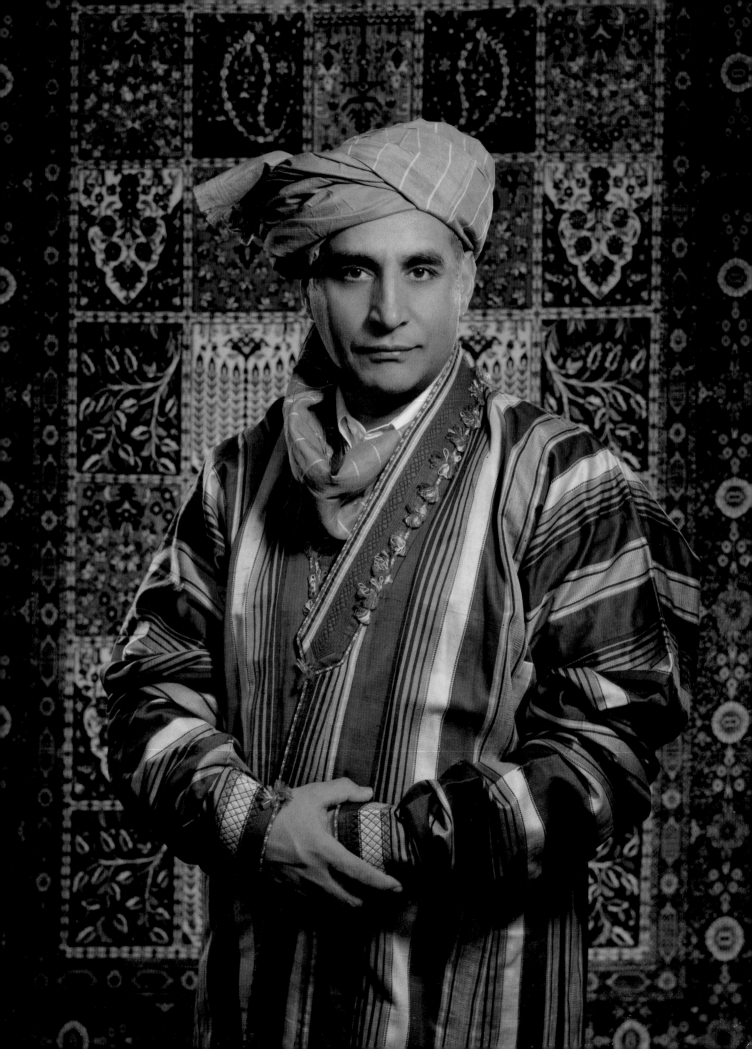

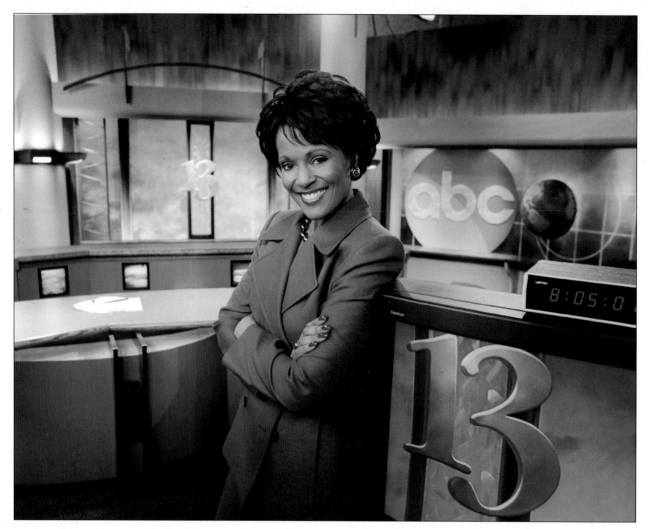

ABOVE—Regina is an anchor for our regional ABC television news show. She was photographed with the tungsten lights of the television studio. I used the modeling light in my umbrella strobe for the main light. (**SUBJECT**—Regina Mobely, news anchor; **DATE**—1999; **CAMERA**—Mamiya RZ67; **FILM**—Fuji NPL tungsten, ISO 160; **LENS**—65mm Mamiya Sekor)

FACING PAGE—Master Adam is karate-do and yoga instructor at the gym I go to. I watched the master, dressed in his black robe, give his class, then asked him to pose for me. We discussed a background, and he mentioned a Buddhist temple. I met Master Adam at the temple for a consultation. I recommended we cover a white wall with black paper and spraypaint a bronze Buddha black to match his robe and the carved stand for the bell. We added an altar for him to sit on, in addition to some religious candles to balance the design. The exposure was made at f-16 and ¼ second. (**SUBJECT**—Master Adam Nguyen; **DATE**—2000; **CAMERA**—Mamiya RZ67; **FILM**—Fuji NPH, ISO 400; **LENS**—65mm)

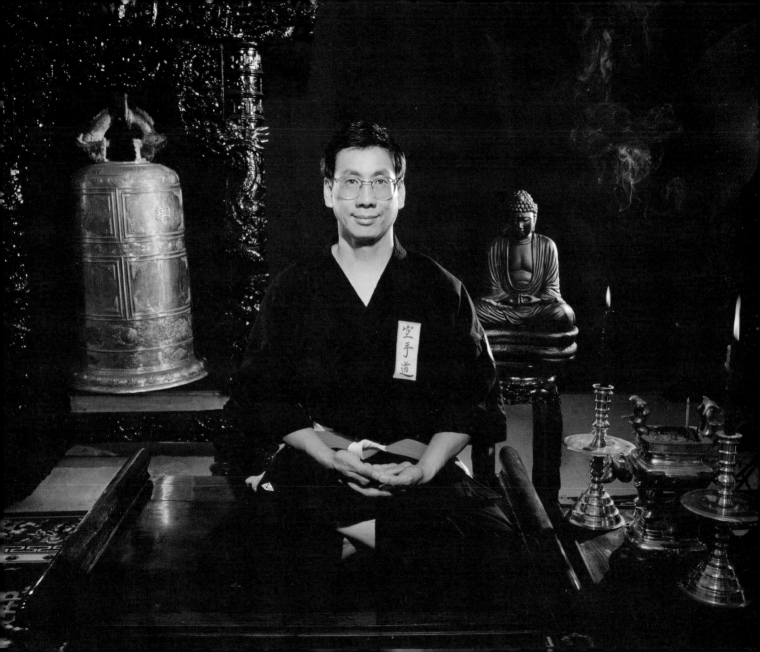

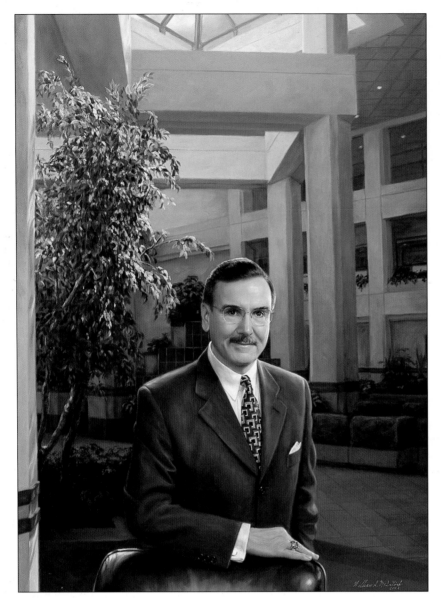

I frequently photograph corporate presidents and board chairmen for major civic institutions and businesses. Because some of these institutions are several hundred years old, many prefer paintings. I have therefore made available an oil-painted photograph. This has the painterly look they want but with the sharpness and realism of a photograph. LaVon Westfall of Sugar Land, Texas, is the artist who does this great work on my portraits, which are usually 30x40- or 40x60-inches in size and displayed in a 4-inch frame.

Most of the time, these are unveiled at a ceremony at the institution. A typical unveiling is shown above.

FACING PAGE—Skip was photographed for *Home and Design Magazine* to feature his home and acknowledge his standing in the field of interior design. The portrait was made in his office. I moved his desk near the archway entrance to the elegant room behind him. The room in the rear was lit by two strobes with barn doors, one directed on the back left wall and one directed on the back right wall behind Skip. The main light was a 31-inch umbrella 45 degrees to the left of my subject. The fill was a 31-inch umbrella behind the camera. The strobes on my subject also lit the wall of his office behind him. The Fuji NPH 400 film enabled me to get a full range of tones with good detail in his dark suit and his hair and hold detail in the light areas. (**SUBJECT**—Skip Sroka, interior designer; **DATE**—2001; **CAMERA**—Mamiya RZ67; **FILM**—Fuji NPH, ISO 400; **LENS**—65mm)

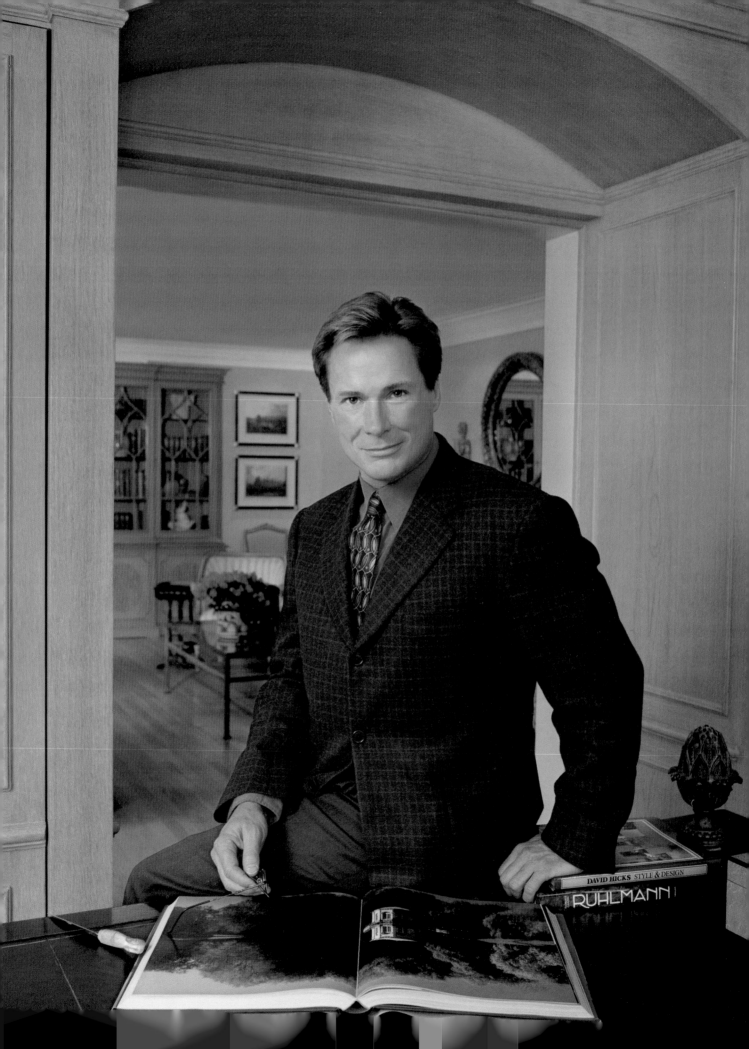

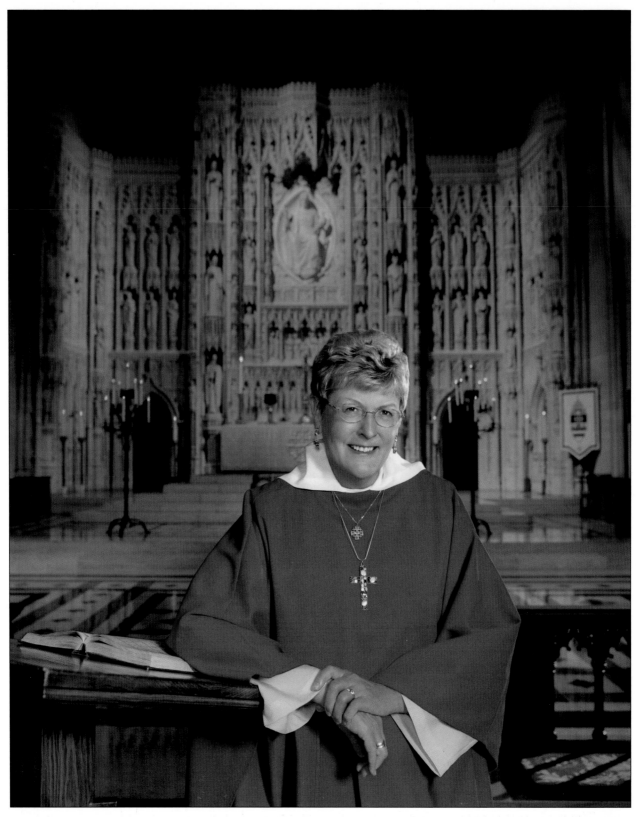

A 30x24-inch portrait was made for the Reverent Brower's home. Three strobes were used on the subject. One skim light was placed 135 degrees to her left. The main light was placed 45 degrees to her left and a fill light was used behind the camera. (**SUBJECT**—The Reverent Anne C. Brower, M.D., Chaplain of the National Cathedral in Washington, D.C.; **DATE**—2003; **CAMERA**—Mamiya RZ67; **FILM**—Fuji NPZ, ISO 800; **LENS**—65mm)

PHOTOGRAPHING THE CULTURAL ARTS

I believe every photographer who puts forth the effort can be innovative and produce portraits of a quality far above their normal output. Most of us start out with great ideas on making portraits that are different and exciting to look at. The problem is, making ends meet always gets in the way, and we end up taking the type of portraits that are easy to make and sell—over and over again. I have been in this trap a number of times; in fact, most of my first ten years in photography was spent making "formula" portraits for money.

Finally, I happened upon a solution that forced me to be innovative and stimulated whatever creative talents I might have. I committed myself to having an exhibition of new work in a large bank lobby that had a changing art exhibit every month. The bank's art committee allowed me, as the only photographer, to exhibit for one

month once a year—as long as my work did not look like the average portrait studio's work.

I scheduled half a day each week to photograph a subject in a different way. I looked for subjects and backgrounds that were unusual and would tell a story. I spared no expense (within my means) in making these portraits possible. I took all my lights, cameras, and anything I needed to make the finest image I was capable of making. If I did not have enough equipment, I borrowed or rented what I needed. The subjects cooperated because there was no charge and they would be in the exhibit. Most bought the portraits with a display discount of 30 percent.

Eventually, my exhibits grew to include portraits of the principal artists of the opera, the symphony, painters, sculptors, cultural and civic leaders, and leaders of the government. Over the years, my exhibits in the bank led to other locations—the opera house, the symphony

hall, home shows, and women's shows, for example. In 1968, The Norfolk Museum of Art (now the Chrysler Museum of Art) honored me with an exhibit of 125 large color canvas portraits of the cultural leaders of the area. In 2001, the Chrysler Museum of Art again honored me with a similar exhibit of my portraits of the area's cultural and civic leaders.

It was over 40 years ago that I began making one portrait a week for myself. It took many years to obtain the credibility needed to hold exhibits in the best public spaces in my area, but it has given me a reputation as an artist in the area. This institutional advertising could not be bought. It is never easy—it takes a lot of time and effort, but in the long run it is well worth it. I keep thinking, where would I be if I had not done it?

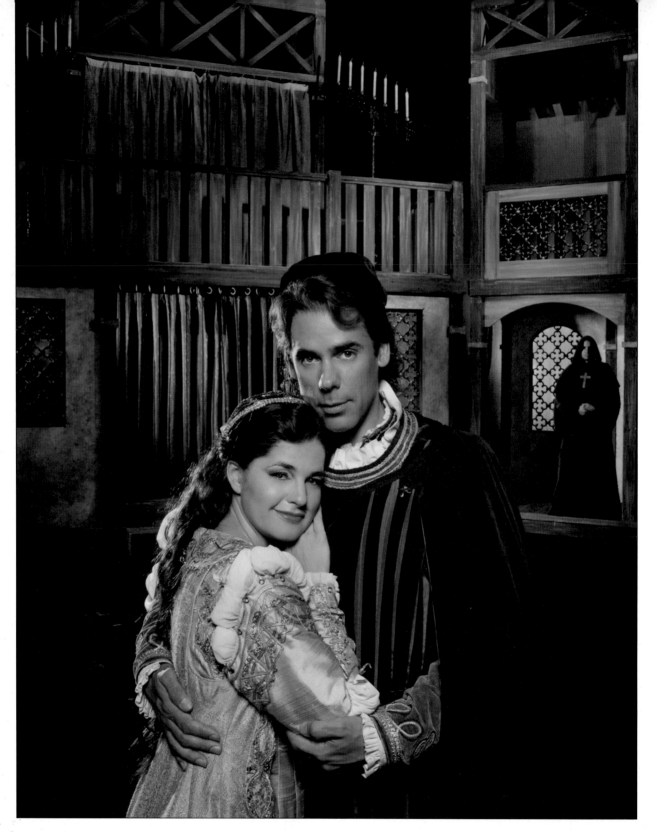

ABOVE—I have been photographing the principals of the Virginia Opera for six years. Each portrait hangs in the Harris Opera House and affords me a permanent showcase for my work. (**SUBJECTS**—Romeo and Juliet; **DATE**—1999; **CAMERA**—Mamiya RZ67; **FILM**—Fuji NHG II, ISO 800; **LENS**—Mamiya Sekor 65mm)

FACING PAGE—Three strobes were used to light Sujung, and four strobes were used to light the two figures in the background (one strobe on each face and body, and one lighting each from the rear to make them stand out from the background). The exposure was ¼ second at f-22 to get detail in the chandelier and keep the figures in the background in focus. (**SUBJECT**—Sujung Kim in *Orfeo and Euridice*; **DATE**—1999; **CAMERA**—Mamiya RZ67; **FILM**—Fuji NHG II, ISO 800; **LENS**—Mamiya Sekor 65mm)

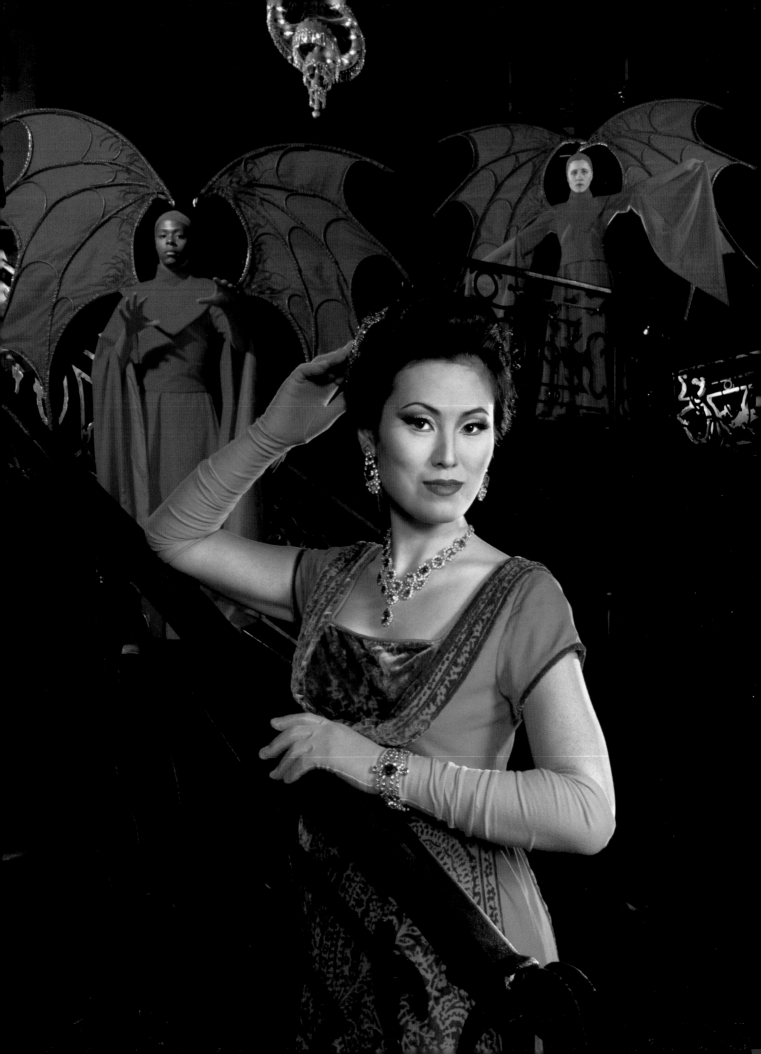

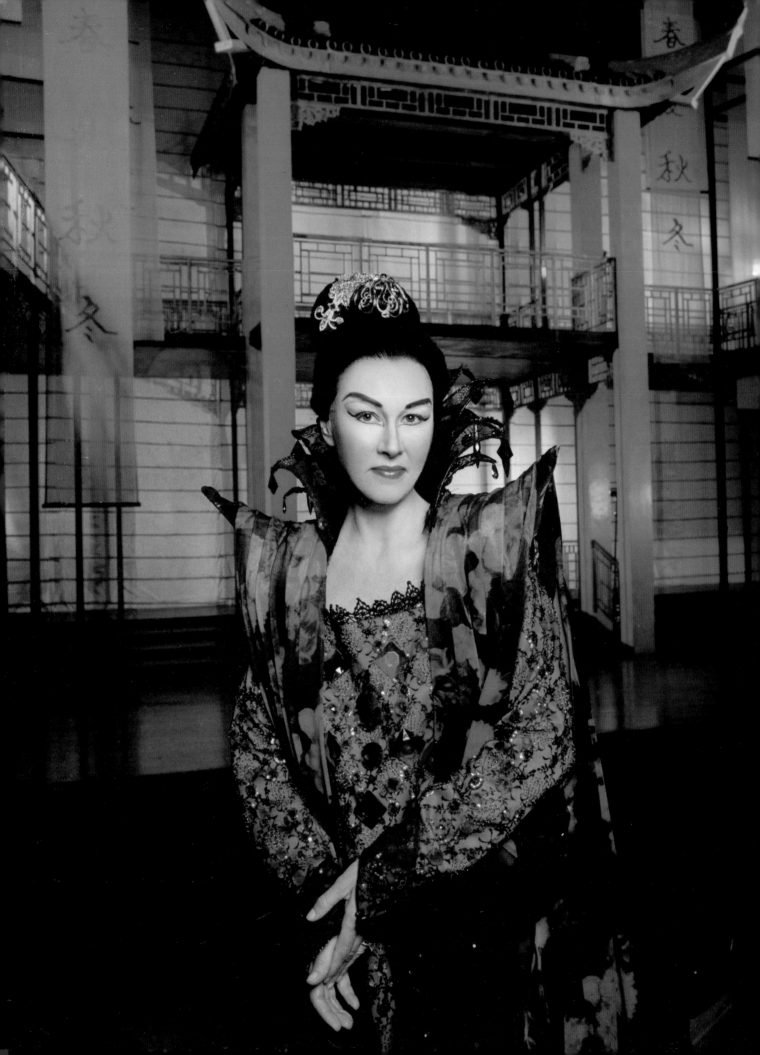

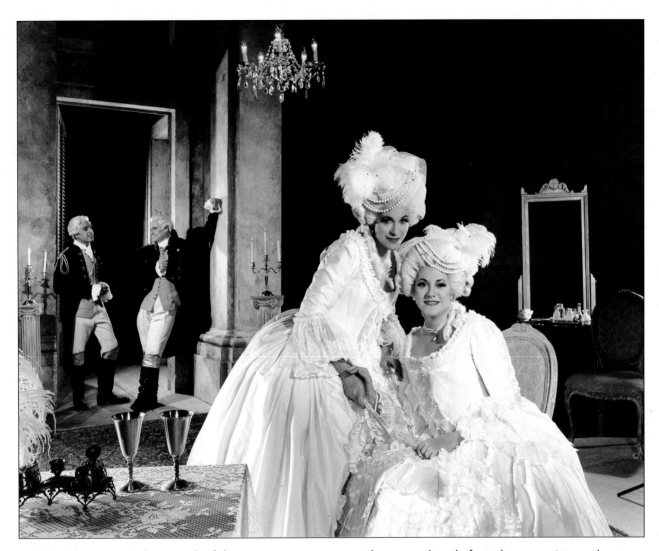

ABOVE—The scenes I photograph of the opera are not necessarily scenes directly from the opera. I move the stage props and the singers around to get the best portrait. Six strobes were used to light the singers and the set. (**SUBJECTS**—Lori and Mary Phillips in *Cosi Fan Tutte*; **DATE**—2000; **CAMERA**—Mamiya RZ67; **FILM**—Fuji NPH, ISO 400; **LENS**—65mm)

FACING PAGE—One 31-inch umbrella was placed high and just above my subject's face, straight on. Six strobes with red and blue gels were used to light the opera set behind the subject. The diva was standing on a banquet table in the first row of the opera house, and so was I. This was necessary in order to get the entire stage set behind her in the portrait. (**SUBJECT**—Irene Bass in *Turandot*; **DATE**—2000; **CAMERA**—Mamiya RZ67; **FILM**—Fuji NHG II, ISO 800; **LENS**—Mamiya Sekor 65mm)

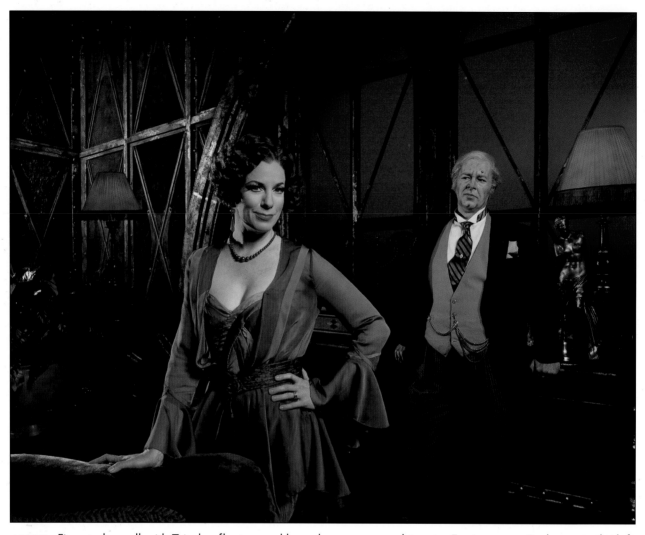

ABOVE—Five strobes, all with 7-inch reflectors and barn doors were used: two on Erwin, one on Rod, one on the left background, and one with a blue filter on the right background. (**SUBJECTS**—Erwin Windle and Rod Nelman in *Don Pasquale*; **DATE**—2002; **CAMERA**—Mamiya RZ67; **FILM**—Fuji NPZ, ISO 800; **LENS**—65mm)

FACING PAGE—Eight strobes with barn doors were used on the background: two on the far background, two on the naval officer, one on the house on the left, and another on Kaori (in the role of Cio-Cio-San) from the right rear as a skim light. The main light on the subject was a strobe with a 7-inch reflector and barn doors, placed 45 degrees to her right. The fill light was a 31-inch umbrella. (**SUBJECT**—Kaori Sato in *Madam Butterfly*; **DATE**—1998; **CAMERA**—Mamiya RZ67; **FILM**—Fuji NPH, ISO 400; **LENS**—65mm)

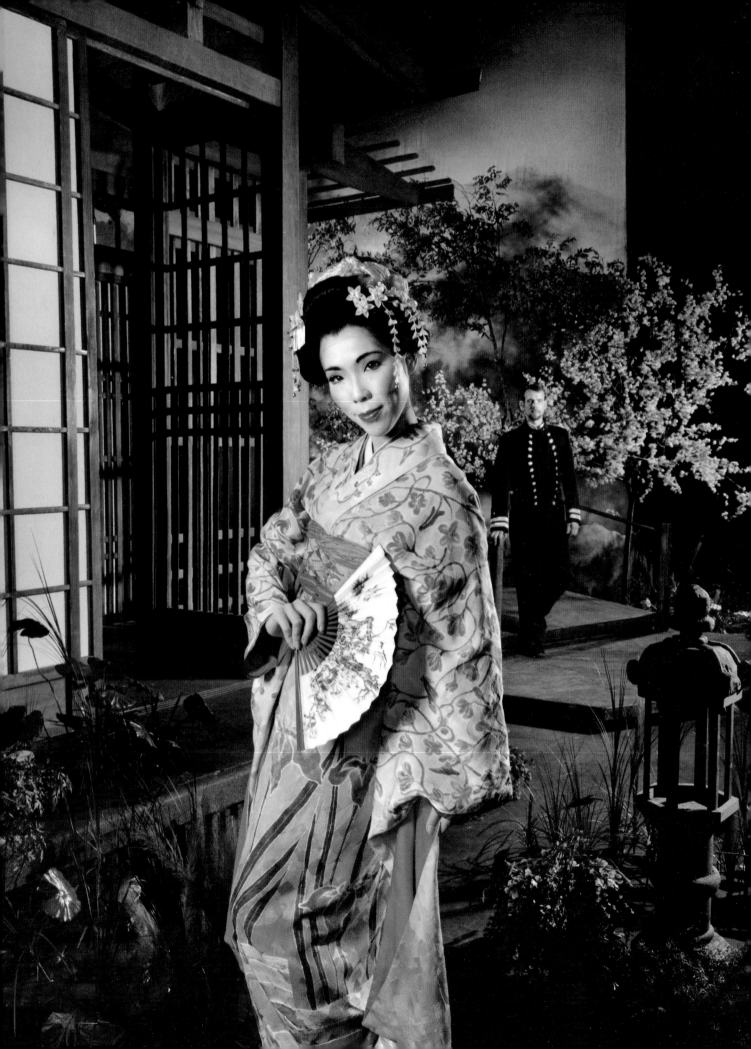

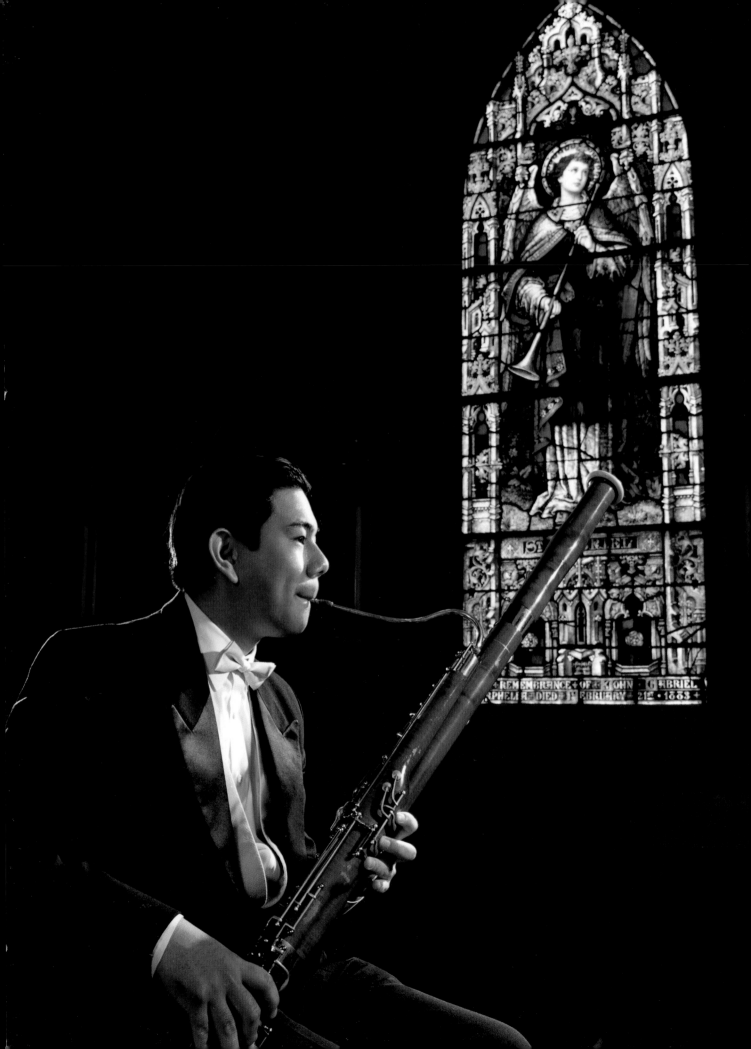

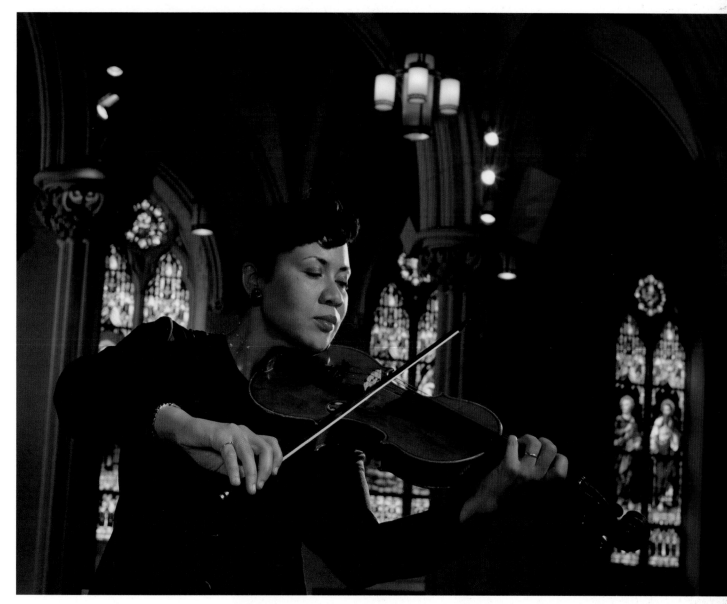

strobe

strobe

strobe

strobe

subject

camera

umbrella

ABOVE—I attended a concert in a beautiful Gothic church several years ago, and viewing the statues and stained-glass windows made me think of some great backgrounds for the first chairs of the Virginia Symphony, whom I was photographing for a new exhibit at the Chrysler Museum of Art. However, the stained-glass windows on most churches are about fifteen feet from the floor. To get my subject more even with the windows in the background, she was standing on two banquet tables, and so was I. Three strobes were used on the subject, and two were used on the ceiling to register some detail. (See lighting diagram.) (**SUBJECT**—Beverly Baker, Principal Viola; **DATE**—1997; **CAMERA**—Mamiya RZ67; **FILM**—Fuji NPH, ISO 400; **LENS**—Mamiya Sekor 65mm)

FACING PAGE—Daniel was photographed while sitting on a chair on top of a banquet table; I was on a ladder and had my camera on a tall tripod. Six strobes were used, two with 7-inch reflectors and barn doors to light the wall on each side of the window. Because proper exposure for the window would have made the walls three stops underexposed, the lights were needed to get some detail. (**SUBJECT**—Daniel Matsukawa, Principal Bassoon; **DATE**—1997; **CAMERA**—Mamiya RZ67; **FILM**—Fuji NPH, ISO 400; **LENS**—65mm)

strobe

strobe

strobe

subject

umbrella

camera

FACING PAGE—Sarah was posed up in the choir loft to get close to the beautiful window. Four strobes were used: a main light, a fill light, a skim light on Sarah, and one light with barn doors skimming the frame of the stained glass window to keep it from going black. (See the lighting diagram.) (**SUBJECT**—Sheri Aguire, Principal Oboe; **DATE**—1997; **CAMERA**—Mamiya RZ67; **FILM**—Fuji NPH, ISO 400; **LENS**—65mm)

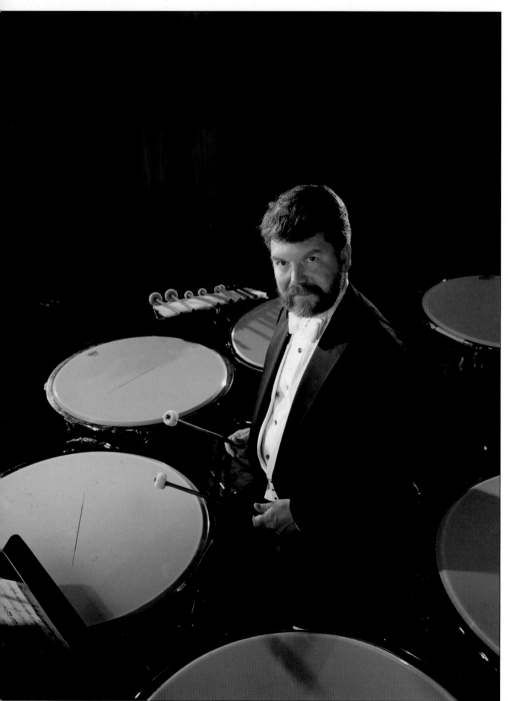

LEFT—One strobe, set for f-8, was directed toward the background. Another, with barn doors closed down, was directed onto the drumsticks behind the subject. Two similar strobes, set for f-11, were placed 135 degrees to the right and left rear of the subject. An umbrella strobe, set for f-11, was placed 45 degrees to the right of the subject. An umbrella fill was set for f-8. (**SUBJECT**—John Lindberg, Principal Timpani; **DATE**—1997; **CAMERA**—Mamiya RZ67; **FILM**—Fuji NPS, ISO 160; **LENS**—65mm)

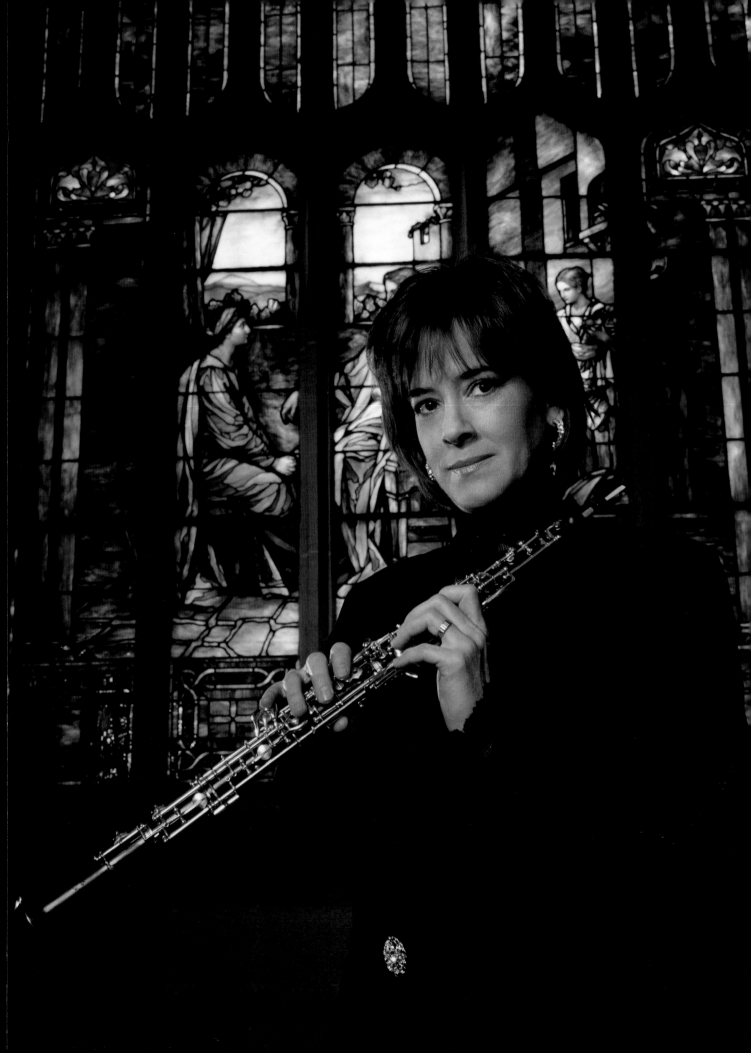

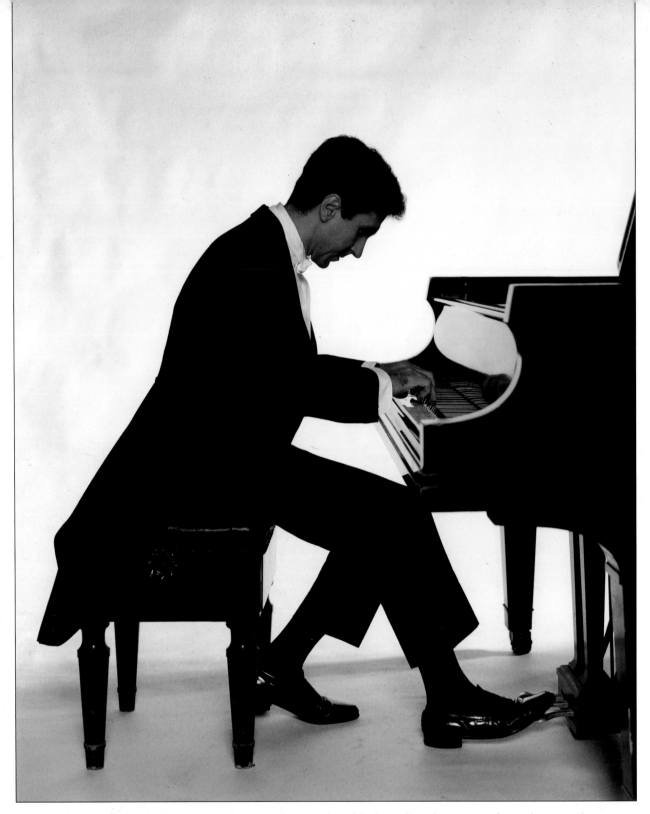

ABOVE—I have always liked this portrait because it is a study in black & white design. A 12-foot white seamless paper background was used. Two strobes lit the background, and one strobe (on a very high light stand and a little to the left of the camera) was positioned on Walter. (**SUBJECT**—Walter Noona, concert pianist and composer; **DATE**—1965; **CAMERA**—4x5-inch SpeedGraphic; **FILM**—Kodak Vericolor film, ISO 160; **LENS**—135mm Schneider)

FACING PAGE—This portrait was made in 1967 before modern high-speed color film was available. One stage spotlight was directed on the couple, while another was focused on the dancers behind the couple. (**SUBJECTS**—Terry Vigillante and Glen White; **DATE**—1967; **CAMERA**—4x5-inch SpeedGraphic; **FILM**—Kodak Type L tungsten, ISO 100; **LENS**—135mm Schneider)

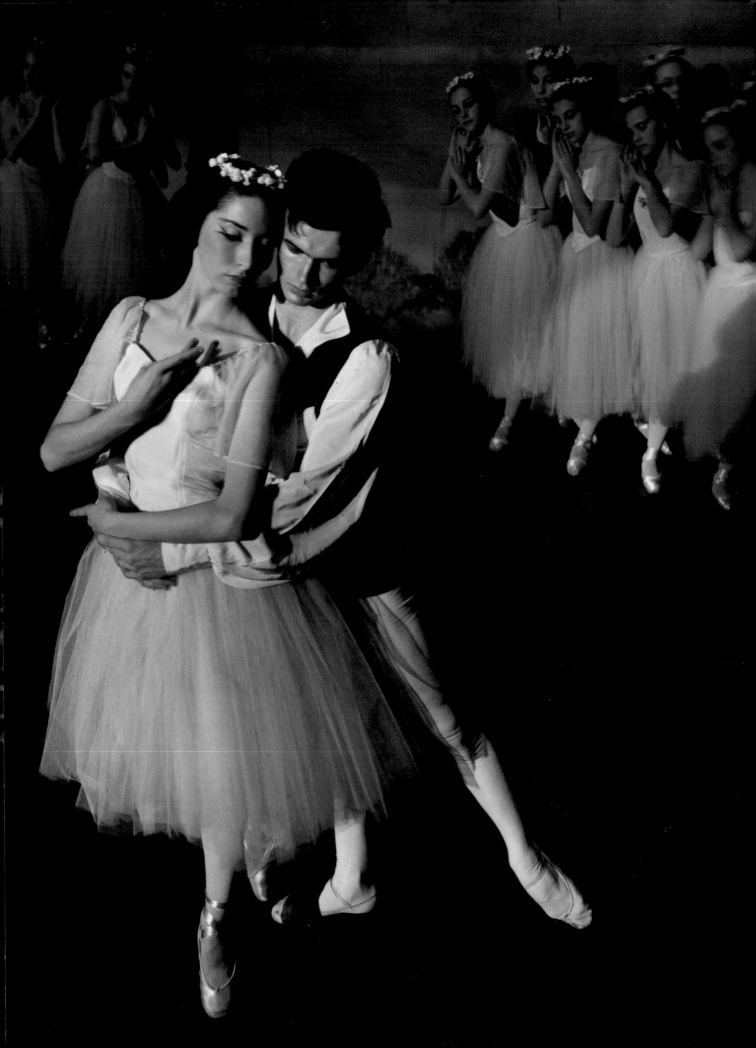

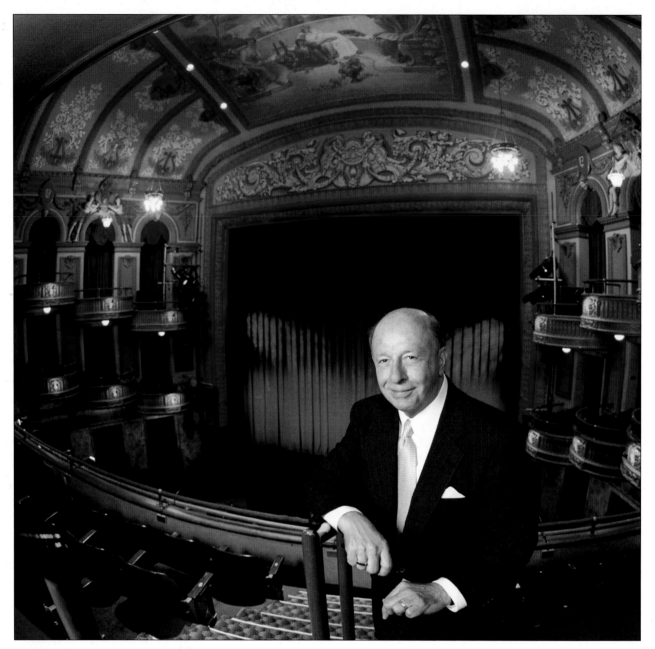

ABOVE—I thought it appropriate that Bob be photographed with the beautifully restored turn-of-the-century movie house behind him. I used a 37mm Mamiya Sekor fisheye lens to get nearly the entire interior of the building. The main light was a 31-inch umbrella, and a similar strobe was used for the fill light. The main light was 45 degrees to Bob's right; the fill was behind the camera. (**SUBJECT**—Bob Brown, founder of The Virginia Stage Company; **DATE**—2001; **CAMERA**—Mamiya RZ67; **FILM**—Fuji NPZ, ISO 800; **LENS**—37mm Mamiya Sekor fisheye)

FACING PAGE—The lobby of this turn-of-the-century theater impressed me every time I attended a play. The idea for the portrait was to use the wonderful illuminated statues as a background for an actor, posed in the Noel-Coward style. The statues were lit with lobby spotlights, but the lighting was uneven and the rest of the lobby would have been totally in the dark without some supplementary lighting. I lit the four statues separately with a strobe and barn doors. The statue behind the actor was only lit with the lobby light, since I did not want it to detract from the actor. Three strobes were directed on the actor. Using 800-speed film allowed an exposure of f-16 at ¼ second to get the depth of field needed and to expose the ambient light properly. (**SUBJECT**—Harald Bullerjahn; **DATE**—2001; **CAMERA**—Mamiya RZ67; **FILM**—Fuji NPZ, ISO 800; **LENS**—65mm)

CHAPTER NINE
THE CHRYSLER MUSEUM OF ART

I have been involved with the Chrysler Museum of Art (formally known as the Norfolk Museum of Art) for about forty years. Any photographer (or artist of any discipline) would do well to take advantage of their local museums. I have made some of my finest portraits using the museum's paintings and sculptures as a background. In 2001, I was honored with an exhibit of my work. It was my privilege during this time to photograph the director and the head curator of the museum. These portraits are included here, along with four others that use the museum's art as a background.

Bill and I took a tour of the museum and decided the most impressive room for the portrait was the hall of statues. The portrait of the museum director could have been made with Fuji NPS 160 film (the only other film with four color layers), but all of the statues except the one on his left would have been very soft, and those in the back would have been out of focus. The light source on the statues was tungsten, and the skylight was late evening daylight supplemented with fluorescent light. The exposure for the ambient light in the background was ¼ second at f-11 with Fuji NPZ 800. I used three strobe lights on the director: one to the left rear with a 7-inch reflector and barn doors, a main light with a 31-inch umbrella, and another 31-inch umbrella behind the camera. The strobe exposure was f-11. Unless the subject is seated and can hold very still, it is impractical to use a shutter speed higher than ½ second. Here, with the ½-second exposure, a 40x60-inch black gobo was placed on two 8-foot light stands over his head to keep the ambient light from the ceiling off his face. (**SUBJECT**—William Hennessy, Director, Chrysler Museum of Art; **DATE**—2001; **CAMERA**—Mamiya RZ67; **FILM**—Fuji NPZ, ISO 800; **LENS**—50mm)

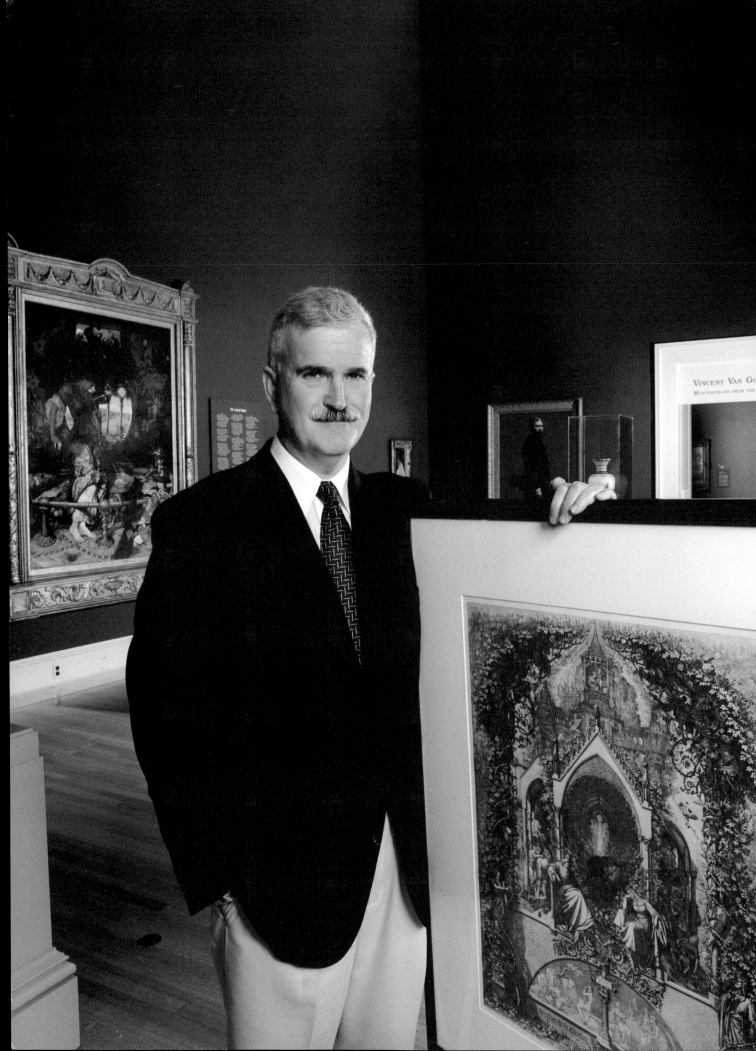

ABOVE—Bess was photographed for an exhibit honoring area women for their contributions to the civic betterment of the community. Bess is of Greek heritage, so I thought it appropriate to photograph her with a Greek statue. Two strobes were used in 7-inch reflectors with barn doors. One was on Bess and the stature, and one was on Bess's hair. (**SUBJECT**—Bess Decker; **DATE**—1975; **CAMERA**—Toyo 4x5-inch; **FILM**—Kodak Vericolor 160; **LENS**—250mm Imagon)

FACING PAGE—Jeffery preferred to be photographed in the room where a masterpiece Pre–Raphaelite painting, *The Lady of Shalott*, was on loan to the museum. Six strobe lights were used: a main, a fill, and a skim light on Mr. Harrison, two lights on the wall of the room he is in, and one in the room showing through the door in the middle background. (**SUBJECT**—Jeffery Harrison, Head Curator, Chrysler Museum of Art; **DATE**—2001; **CAMERA**—Mamiya RZ67; **FILM**—Fuji NPZ, ISO 800; **LENS**—65mm)

ABOVE—The background for this portrait is an Edgar Degas painting, *Dancer with Bouquets*. Five strobes were used: three with 7-inch reflectors and barn doors (one lighting the painting, two skims), and two with 31-inch umbrellas (one main and a fill). I used soft focus to create a dream-style image. (**SUBJECT**—Susan Via, violinist; **DATE**—1991; **CAMERA**—Mamiya RZ67; **FILM**—Kodak Vericolor III, ISO 160; **LENS**—150mm Mamiya Sekor soft focus)

FACING PAGE—This is a studio portrait, but I moved the studio to the Chrysler Museum of Art to make it. Two strobes were used on the white background. The main light, with a snoot, was directed onto the model's face. A strobe with a 7-inch reflector and barn doors was directed on her hair and the face of the statue. The fill light was a weak 48-inch umbrella behind the camera, and the white statue also served as a fill source. This portrait was made for the Polaroid Corporation to promote 8x10-inch Polaroid film. (**SUBJECT**—Model with marble statue; **DATE**—1978; **CAMERA**—Toyo 8x10-inch; **FILM**—Polaroid 8x10-inch ER; **LENS**—19-inch Imagon)

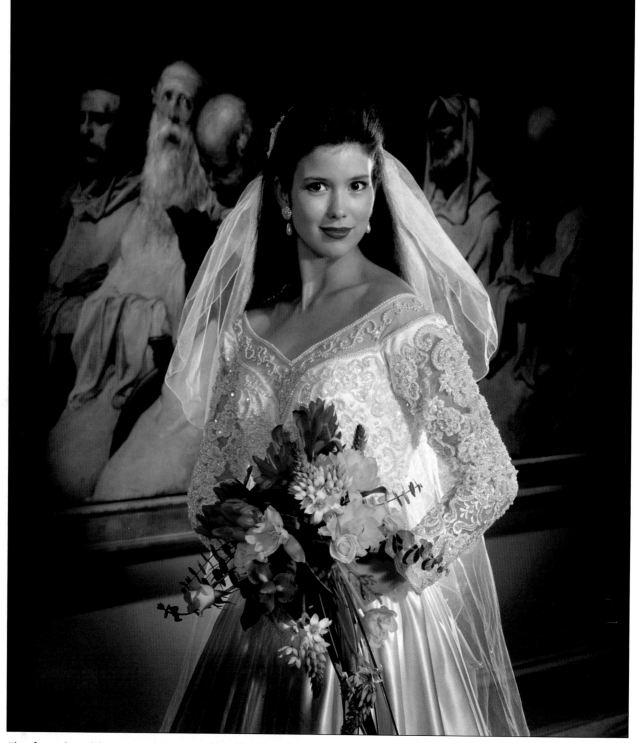

This formal wedding portrait was made in the Chrysler Museum of Art as an advertisement for a bridal salon. In the background, I used the painting *The Neophyte* by Gustave Dore (1834–1917), which shows five monks, one of whom seems to be looking at the subject with possible second thoughts about being a monk. The portrait takes the bridal portrait out of its usual church background, but it still has a religious theme. The model's face was lit with a grid strobe that only lit her face. Another strobe, with a 7-inch reflector and barn doors, was directed only on her dress. (Using only one light on the entire figure, as most formals are lit, will not give the detail and brilliance to the gown that lighting the face and gown separately will.) One skim light was used on her veil, placed 135 degrees to the left rear of the subject, and a similar strobe was used to light the painting. A 40x40-inch white reflector was placed on the subject's left side. (See lighting diagram.) (**SUBJECT**—Lori Batemen; **DATE**—1994; **CAMERA**—Mamiya RZ67; **FILM**—Fuji NPH, ISO 400; **LENS**—65mm)

PHOTOGRAPHING ARTISTS (AND A WRITER)

Another ongoing project I have been involved in is photographing the top Virginia artists. Every ten years or so I have an exhibit that hangs in a gallery or some public place. I receive a painting or piece of sculpture in exchange for every artist I photograph.

Bob Holland, whose work tends to be of medium-toned marine scenes, liked the idea of a darker image and a black sweater. I felt this would allow me to concentrate on his strong face and get the "artist" look that I thought would do him justice. To light the portrait, I used three strobes, all with barn doors. One was used on the background, one skimmed on his right side, and one was the main light, placed right over the camera. (**SUBJECT**—Bob Holland, artist; **DATE**—2000; **CAMERA**—Mamiya RZ67; **FILM**—Fuji NPS, ISO 160; **LENS**—110mm)

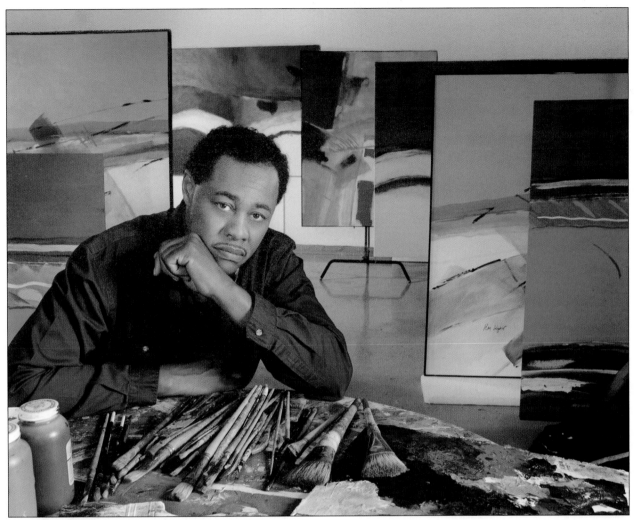

ABOVE—This is a study in color harmony. I placed Ken's paintings so the colors would blend and enhance the subject. Ken was wearing a maroon shirt, so the paintings in the background were arranged to harmonize with his shirt and his palette of paints—even the two jars of paint have the colors echoed in the background. Six strobes were used; one main, one fill, and one skim on Ken, and three strobes to light the paintings. (**SUBJECT**—Ken Wright, artist; **DATE**—2000; **CAMERA**—Mamiya RZ67; **FILM**—Fuji NPH, ISO 400; **LENS**—65mm)

FACING PAGE—I used three strobes to create this portrait. Two 31-inch umbrellas were used on George, and one 7-inch reflector with barn doors was used on the background. (**SUBJECT**—George Tucker, newspaper columnist and author; **DATE**—2000; **CAMERA**—Mamiya RZ67; **FILM**—Fuji NPH, ISO 400; **LENS**—65mm)

CHAPTER ELEVEN
PHOTOGRAPHING THE MILITARY

I began photographing our senior military leaders in 1992 for a traveling exhibit for The Navy League. The theme of the exhibit was to acquaint the public with our senior military leaders. Since then, I have photographed many of the Joint Chiefs of Staff, and all of our admirals of the Atlantic Fleet and the heads of our joint forces command. I also included some junior officers to round out the exhibit.

I arrived early at the command center of the Joint Chiefs of Staff to set up. Members of General Powell's military staff were placed around the table. Tests for lighting and posing were all complete before the general arrived. The actual photo session only took twenty minutes. I used Fuji Reala 100 film to record the ambient and fluorescent light without a greenish tint. (**SUBJECT**—General Colin L. Powell (Ret.); **DATE**—1992; **CAMERA**—Mamiya RZ67; **FILM**—Fuji Reala, ISO 100; **LENS**—65mm)

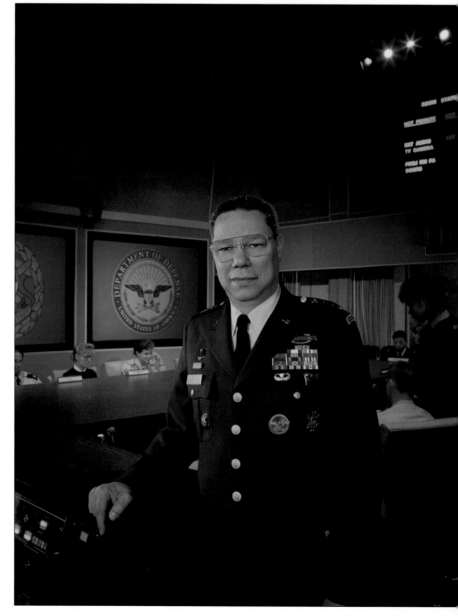

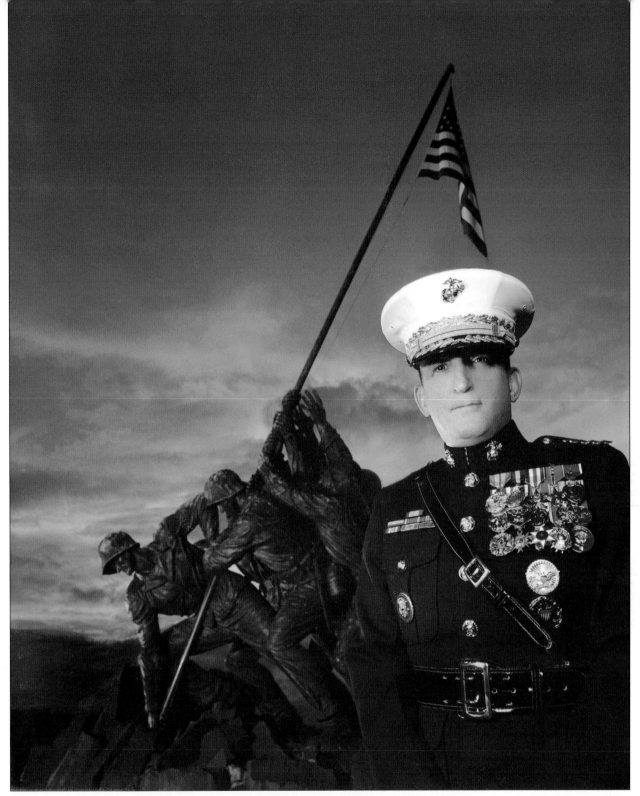

The Iwo Jima statue in Washington, D.C., was chosen as a background for this portrait of General Krulak, the Commandant of Marines. The statue is 70-feet high, and the best time to photograph it is at sunset. My assistants and I met eight marines at 4:00pm to set up for the shoot at 7:30pm. The marines set up a scaffold 6-feet high and 8-feet square to get the general, myself, my camera, and the lights up high enough for the best perspective on the statue. The sky was just right at about 7:45pm. I made twenty exposures in about five minutes. Seven strobes were used. The main light and fill were 31-inch umbrellas. A 7-inch reflector with barn doors was used as a skim light on the General. I wanted the statue to stand out, so I lit it separately, placing a White Lightning 900 watt-second strobe with a 13-inch wide-angle reflector 13 degrees to the left rear of the statue. A similar unit was placed 60 degrees to the left of the statue. A Travelite 750, with a wide-angle reflector, was placed 45 degrees to the left, and another similar strobe was hidden behind the general and directed onto the statue to fill in the deep shadows. (**SUBJECT**—General Charles C. Krulak, United States Marine Corps (Ret.); **DATE**—1997; **CAMERA**—Mamiya RZ67; **FILM**—Fuji NGHII, ISO 800; **LENS**—65mm)

FACING PAGE—The battleship Wisconsin came to Norfolk, VA, as its final resting place at the Nauticus Naval Museum. It is a wonderful addition to the oldest seaport in the nation. An 8-foot scaffold was erected to get the best angle for the admiral, myself, the camera, and a Lumedyne bare-bulb strobe. The exposure just before the sun went down was ¹⁄₁₅ second at f-11. (**SUBJECT**—Admiral Robert J. Natter, United States Navy, Commander of the Atlantic Fleet (Ret).; **DATE**—2001; **CAMERA**—Mamiya RZ67; **FILM**—Fuji NPZ, ISO 800; **LENS**—65mm)

BELOW—This portrait was made on the narrow catwalk of the bridge of the carrier. There was room only for the captain, myself, my camera, and my Lumedyne strobe. The shadow of the pilot house completely covered the captain. I fitted the strobe with a 5-inch reflector to get enough light to match the noon light on the aircraft below. The strobe was attached to a monopod and held out in space to the right of the captain. The exposure was ¹⁄₁₂₅ second at between f-11 and f-16. The strobe exposure was the same. (**SUBJECT**—Captain Robert G. Sprigg, United States Navy, Commander of the U.S.S. George Washington aircraft carrier; now, Rear Admiral (Ret.); **DATE**—1994; **CAMERA**—Mamiya RZ67; **FILM**—Fuji NPS, ISO 160; **LENS**—65mm)

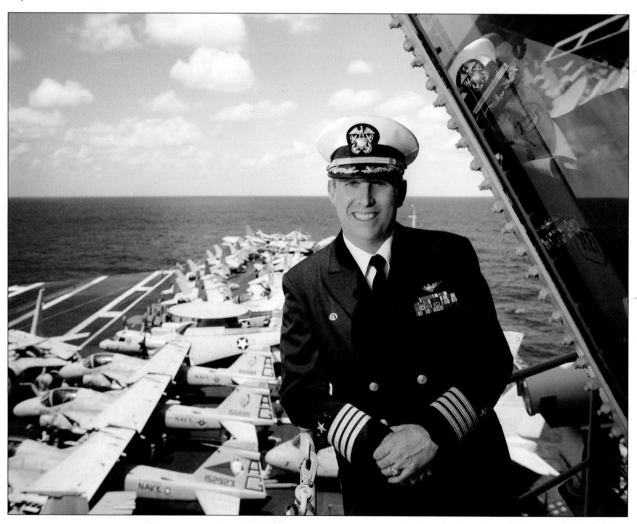

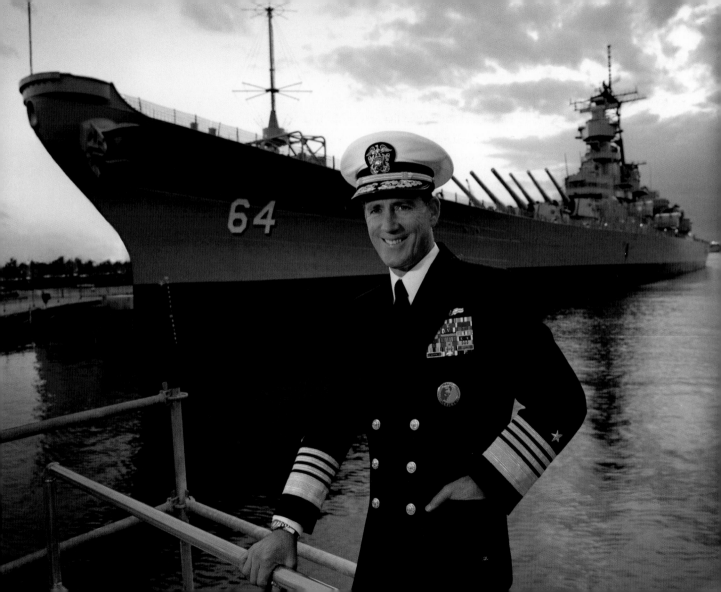

General Kernan was photographed at his office at the Supreme Allied Command Building. The flags of his multiple commands, along with other artifacts collected over his long years of service, were placed in the portrait to make a meaningful design. (**SUBJECT**—General William F. Kernan, United States Army (Ret.), Supreme Allied Commander of the Atlantic, Commander-in-Chief of the United States Joint Forces; **DATE**—2001; **CAMERA**—Mamiya RZ67; **FILM**—Fuji NPS, ISO 160; **LENS**—65mm)

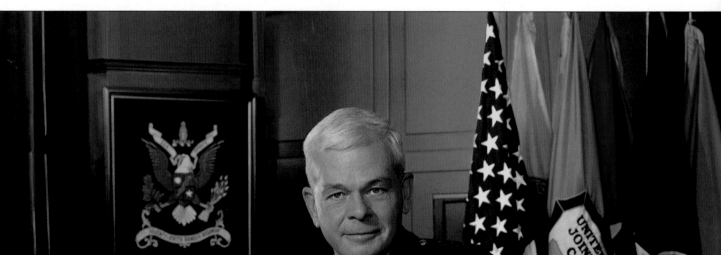

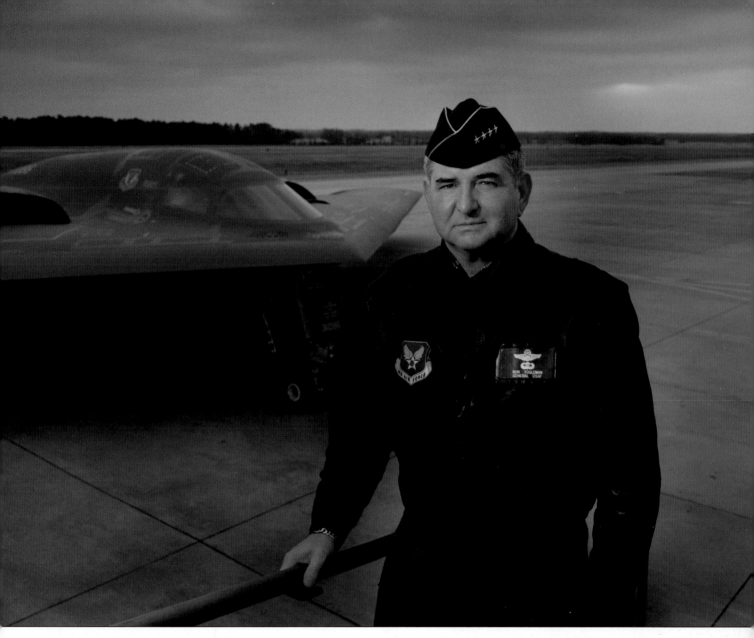

The Air Force felt the B2 Stealth Bomber would make a fine background for the General. We met at the Pope Air Force Base in North Carolina, at sunset on a chilly and windy day in January. I was at the top of a very narrow 30-foot ladder platform with my assistant, George Allan, and the general was only two steps below us. George held a monopod with the bare-bulb strobe attached at a 45-degree angle out in space to the left of the camera. It was very cold and uncomfortable, but the General was a good sport and allowed me the time needed to get a fine portrait. The ambient light was f-11, and I set the bare-bulb strobe for f-11. The exposure was f-11 at $\frac{1}{30}$ second. (**SUBJECT**—General Ronald R. Fogleman, Chief of Staff, United States Air Force; **DATE**—1997; **CAMERA**—Mamiya RZ67; **FILM**—Fuji NGHII, ISO 800; **LENS**—65mm)

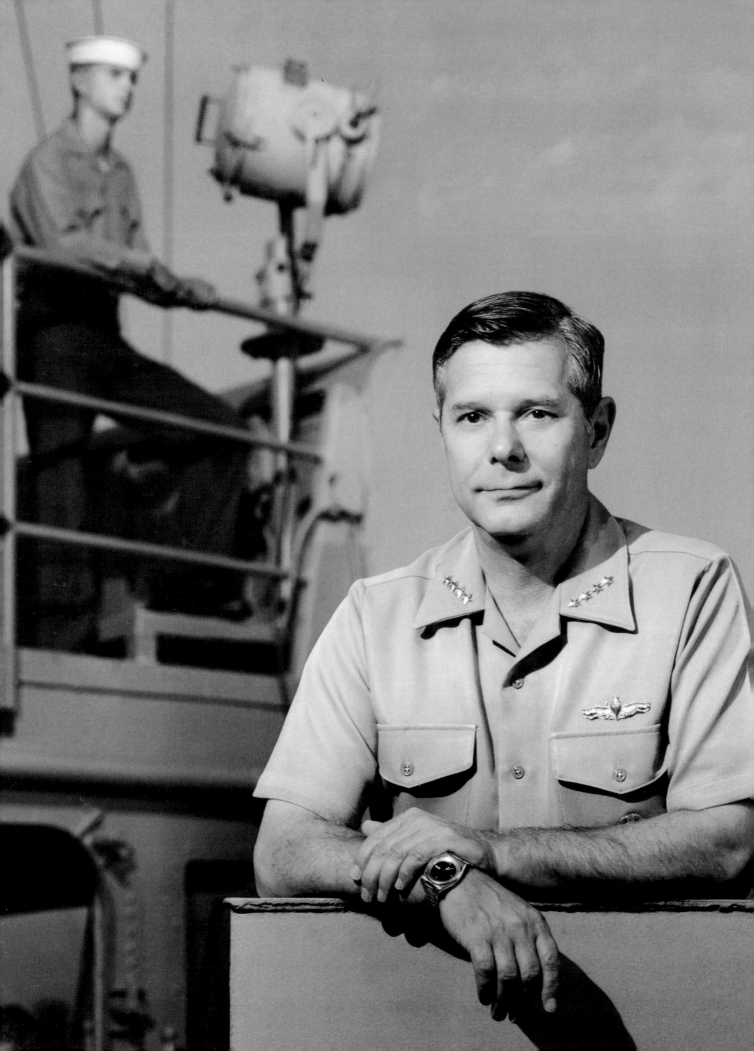

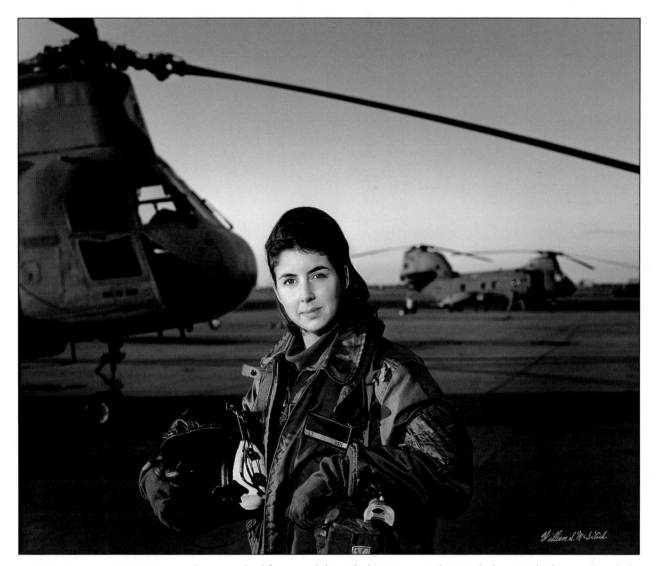

ABOVE—Lieutenant Yeager was photographed for an exhibit titled "Women in the Workplace," which was to include women in the Hampton Roads metropolitan area. The Navy's public relations department recommended Lieutenant Yeager for the exhibit. Lieutenant Yeager and I met at the helicopter section of the Navy Air Station about an hour before sunset. I selected a perfect site between two helicopters, and we waited for the sun. Just as the last rays of the sun lit the helicopter and Tracy at a 90-degree angle to the left of the camera, I filled in the shadow side of her face with a weak Lumedyne bare-bulb strobe and made twenty quick exposures, changing the pose a little and bracketing to get the strobe at the right balance with the sun. (**SUBJECT**—Lieutenant Tracy Yeager, United States Navy; **DATE**—1999; **CAMERA**—Mamiya RZ67; **FILM**—Fuji NPH, ISO 400; **LENS**—65mm)

FACING PAGE—Admiral Boorda was the only Admiral to rise from an enlisted man to the top rank in the Navy. I photographed him on the destroyer Barry in the Washington, D.C., navy yard. The day before the session, I toured the Barry for the best site for the portrait. I suggested we place an enlisted man in the background to symbolize the admiral's advancement through the ranks. A tall tripod and ladder was used to get a good angle. The lighting was the same as that used in General Fogleman's portrait (previous image). (**SUBJECT**—Admiral Jeremy Michael Boorda, United States Navy, Chief of Naval Operations [1994–1996]; **DATE**—1994; **CAMERA**—Mamiya RZ67; **FILM**—Fuji NPH, ISO 400; **LENS**—65mm)

PORTRAITS IN THE HOME

The easy way to make portraits in the home is to take two umbrella strobes, pose the family on a sofa or stuffed chair or in front of the fireplace, and make the exposures. My method is a lot more involved. I like to tell a story about the people by including space around them and filling the space with their paintings, sculpture, personal artifacts, flowers, or anything they would like included in their portrait. I pose them in the foreground in an attractive arrangement and light the background like I was making a fine portrait of their home for *Architectural Digest* magazine.

I visit the home before the session, consult with the patron, and decide with them how the portrait will be made. We talk about what clothes to wear and, if there are children who are two to seven years old, I advise the parents to keep them out of sight while my assistant and I are setting up the equipment. My method of photographing children is to surprise them by making up stories about my stuffed animals and squeaky toys. If they watch us getting ready for the shoot, there is no surprise and they are bored with us before we start.

I use wide-angle lenses for most all of my home portraits. I carry at least four strobes with me, and for a large room with other rooms behind it, I may carry six or seven strobes.

FACING PAGE—The most impressive feature of the Bajah home is the foyer with the double staircase. I moved a settee from the living room to the foreground and posed the family on it. There was a window high up over the main entrance, casting a soft ambient light. I lit the family with a main strobe and fill. Two strobes with 7-inch reflectors and barn doors were concealed under each staircase, one lighting the flower arrangement and the other lighting the opposite wall with the painting. A 37mm Mamiya Sekor fisheye lens was used to include nearly all the foyer from top to bottom—and the entire staircase. (**SUBJECT**—The Bajah family; **DATE**—2002; **CAMERA**—Mamiya RZ67; **FILM**—Fuji NPH, ISO 400; **LENS**—37mm Mamiya Sekor fisheye)

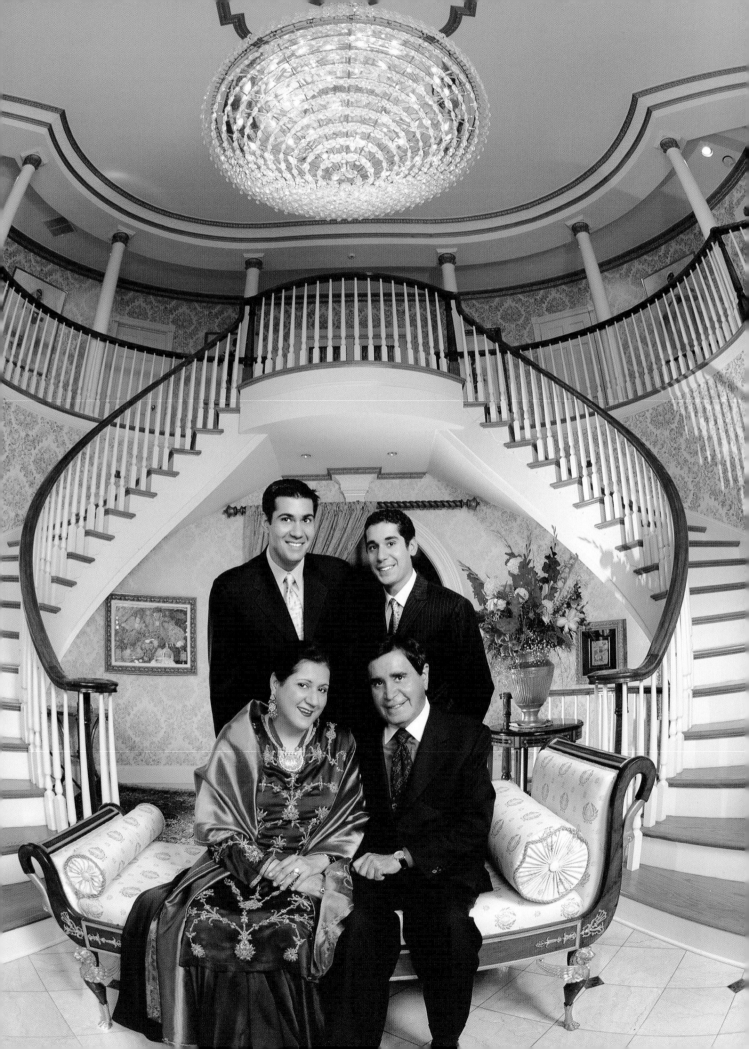

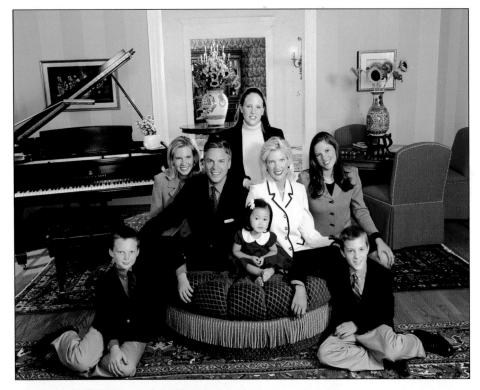

TOP LEFT—The Huntsman family was photographed for *Home and Design Magazine*. The magazine had the Huntsman home photographed by an architectural photographer and asked me to make a portrait of the family. For this portrait, I combined portrait lighting with architectural lighting. The main light was a strobe in a 31-inch umbrella placed 45 degrees to the right of the camera. A similar strobe was behind the camera as a fill light. A strobe with barn doors was placed in the foyer, backlighting the group. Two strobes with barn doors lit the right and left walls of the foyer and the vase with the sunflowers. The room in the back with the red patterned wall was lit with one strobe bounced off the ceiling. The exposure was 1/4 second at between f-16 and f-22 to show the candles in the foyer and back room. (**SUBJECTS**—The Huntsman family; **DATE**—2002; **CAMERA**—Mamiya RZ67; **FILM**—Fuji NPH, ISO 400; **LENS**—65mm)

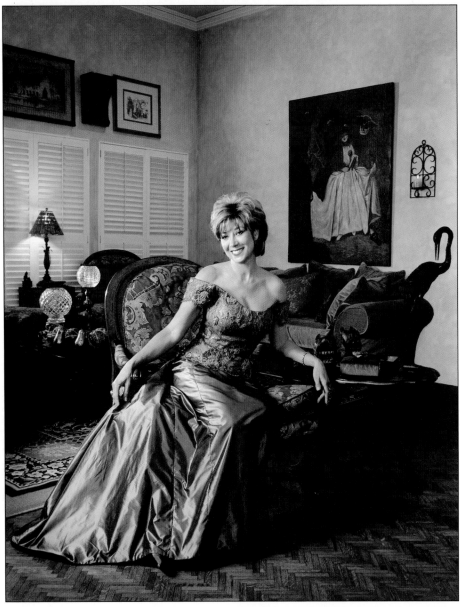

BOTTOM LEFT—I photographed Olivia in her home in Fort Worth, TX. The crane sculpture on the right back wall was brought in from another room. The chair, the table on her left, and the coffee table on her right (with the artifacts and lit candles) were all moved to fill the space around Olivia. The green gown was selected to harmonize with the carpet, the sofa in the background, and the green in the design on the chair. Four strobes were used: two with barn doors (one on the background, one as a skim light), two with 31-inch umbrellas (one main, and one fill). (**SUBJECT**—Olivia Kearney; **DATE**—2001; **CAMERA**—Mamiya RZ67; **FILM**—Fuji NPS, ISO 160; **LENS**—65mm)

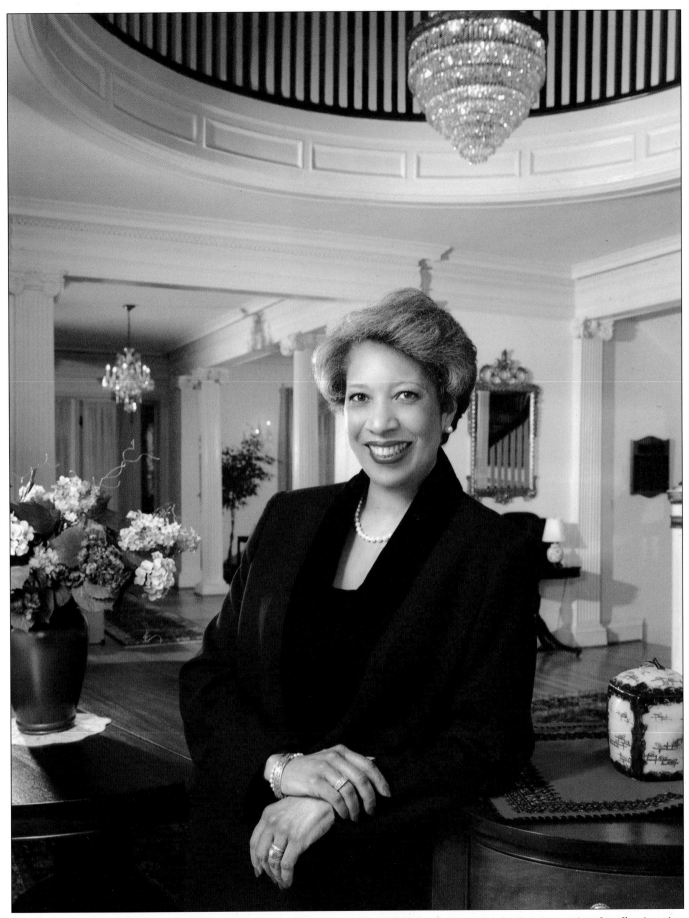

Dianne lived in the Virginia House with her husband, Admiral Paul Reason (Commander in Chief, US Atlantic Fleet [Ret.]), when this was made. The foreground tables were moved to fill the empty space and balance the pose. Six strobes were used: three on Dianne (two with 31-inch umbrellas, one with barn doors as a skim light), one on the flowers, one on the back room, and one on the back wall (each with barn doors). (**SUBJECT**—Dianne Reason; **DATE**—1999; **CAMERA**—Mamiya RZ67; **FILM**—Fuji NPS, ISO 160; **LENS**—65mm)

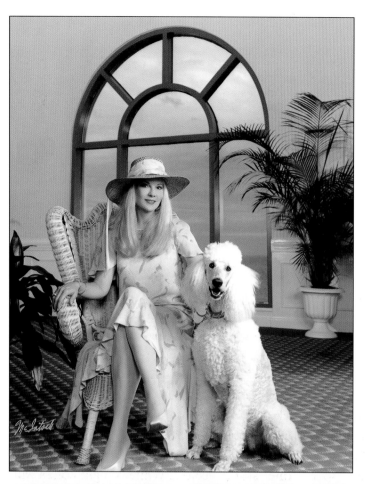

LEFT—I made this portrait for *Home and Design Magazine*. Lee and I consulted on using this beautiful dog in a portrait, and we came up with a summery statement with the big window overlooking the Atlantic as a background. I used four strobes: two 31-inch umbrellas and one 7-inch reflector with barn doors as a skim light were used on Lee; one reflector with barn doors was used on the background. (**SUBJECT**—Lee Milteer, motivational speaker; **DATE**—2000; **CAMERA**—Mamiya RZ67; **FILM**—Fuji NPS, ISO 160; **LENS**—65mm)

BELOW—Nate is a photographer and the owner of the Custom Color Photo Lab. For this portrait, I moved the table with the flowers and bowl to hide the space in the fireplace. Usually I use a fire, but I thought the flowers would add more. Five strobes were used: three on my subjects (two 31-inch umbrellas for main and fill, one 7-inch reflector as skim light), and two on the back right and left walls (7-inch reflectors). (**SUBJECTS**—Nate and Mary Agnes Accardo; **DATE**—1996; **CAMERA**—Mamiya RZ67; **FILM**—Fuji NPS, ISO 160; **LENS**—65mm)

THE GARDEN PORTRAIT

Most of my garden portraits are made with the subjects in the shade and the sun behind them. I light them with a Lumedyne battery strobe and usually match the strobe exposure with the ambient light.

When making a portrait in total shade, you can overexpose the film by one stop, but a heavy overcast sky and deep shade will absorb more of the longer (red) wavelengths of light. This will leave the red-sensitive layer of color film underexposed and produce a cyan/blue cast in the shadow areas. Adding additional strobe to illuminate the subjects will rectify this (being balanced for daylight), but this does not light the background, so the problem is only partly solved. The solution is to lower the shutter speed one stop, allowing more red light through to the film. Since the subjects are predominately lit by the strobe, the longer shutter speed will only affect those areas beyond or outside the range of the strobe.

I recommend clothes that are neutral (black, white, or gray) or cool colors (in the blue or green family). Remember that warm, earthy colors advance and cool colors recede. All people have earthy or warm flesh tones, so their faces will generally show up better if the clothes or background are cool colors. White or light colors will make people look bigger, and black or dark colors will make people look smaller. The light will also bounce off a light-colored blouse or shirt and make the subject's face and neck look larger. Dark clothes will show more shadow and make the subject's face look smaller.

FACING PAGE—Rachael and Rebecca were photographed at the Norfolk botanical gardens with the late afternoon sun behind them. My assistant held a piece of cardboard above my lens to keep the sun from shining directly into it. (**SUBJECTS**—Rachael and Rebecca Foley; **DATE**—2000; **CAMERA**—Mamiya RZ67; **FILM**—Fuji NHG II, ISO 800; **LENS**—90mm)

TOP RIGHT—The idea for this portrait was to make a retro-style image with the family's new Prowler. The car was parked on the hill in their yard, and I stood on a ladder looking down on my subjects. The scene was backlit, with the ambient light and the bare-bulb flash reading ⅟₁₅ second at f-11. (**SUBJECTS**—The Hayes family; **DATE**—2000; **CAMERA**—Mamiya RZ67; **FILM**—Fuji NPH, ISO 400; **LENS**—37mm fisheye)

BOTTOM RIGHT—Lady Perowne is the wife of Admiral Sir James Perowne, and the portrait was made at the official residence of the Deputy Supreme Allied Commander of NATO. The Admiral was photographed inside, and Lady Perowne was photographed in the garden. The time was 11:00a.m. The bench and the potted flowers were moved close to the water and the overhanging branch. The front of my subject was in the shade of a tree, with the sun on her back. The lighting was a bare-bulb strobe set for f-11. The background was overexposed one stop at ⅟₅₀₀ second at f-11. I used a 140mm lens to soften the background; if it were sharp, it would have detracted from my subject. (**SUBJECT**—Lady Nichole Perowne; **DATE**—2001; **CAMERA**—Mamiya RZ67; **FILM**—Fuji NPZ, ISO 800; **LENS**—140mm)

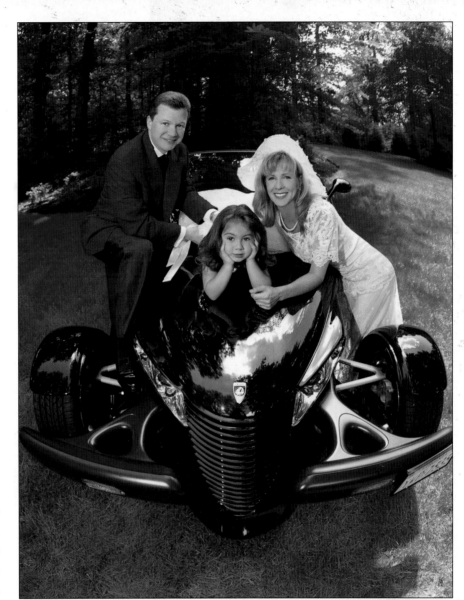

Carol Vero, the oldest sister, arranged this portrait as a birthday gift for her mother. I consulted with Carol on clothing. I always recommend long sleeves on everyone except young children. Elbows, arms, bare legs, and knees detract from the faces in a group. Carol liked the idea of red sweaters for everyone and bought several so they would all match. Cool clothes, as a general rule, look better, but any color can be used; it is more important that they match and blend with each other. Muted designs will work also, as long as they are coordinated with everyone in the group. My subjects were posed on a slanted sand dune. I look for slanted terrain for my groups; it makes for a more interesting composition. You can see some sitting, some standing, and some kneeling to make a nice asymmetrical triangle design. (**SUBJECTS**—The Vero family; **DATE**—1999; **CAMERA**—Mamiya RZ67; **FILM**—Fuji NPH, ISO 400; **LENS**—65mm)

To get an unobstructed background I had to use my 6-foot ladder and get up high enough to crop out a house. The image was made in late afternoon sunlight (f-8) with a bare bulb strobe set at f-8. The exposure was $\frac{1}{125}$ second at f-8. (**SUBJECT**—Megan Ellmere; **DATE**—2001; **CAMERA**—Mamiya RZ67; **FILM**—Fuji NPH, ISO 400; **LENS**—65mm)

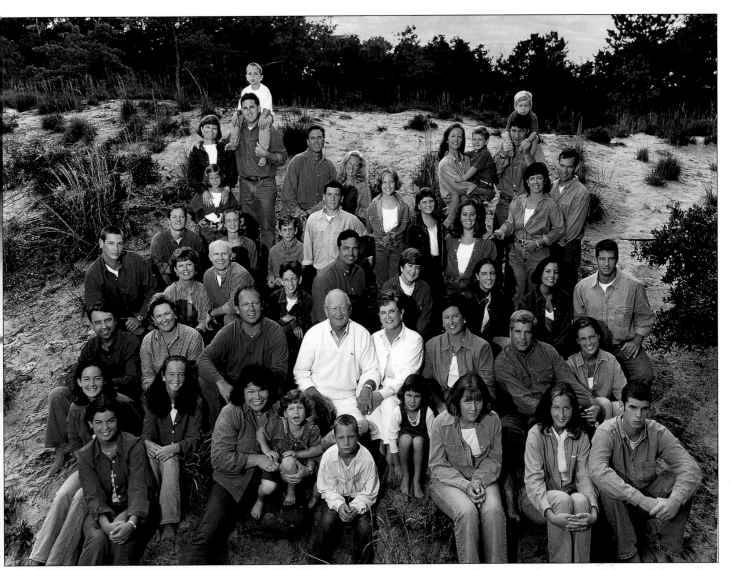

Billy and Ellen Callahan have been friends of ours for over forty years. They have nine children and 36 grandchildren. To photograph a group this size you have to use risers—or photograph them on the side of a hill. The sand dune worked out just right. I was on a 10-foot ladder with a 10-foot tripod, so the angle of the camera was closer to the middle of the group than the front row. If the portrait were made at ground level, the people in the front row would appear about three or four times larger than those in the seventh row. I used a Lumedyne strobe with a 5-inch reflector set for wide angle to give more than one stop more light than the bare bulb. This was needed because the bare bulb was not strong enough to reach the group. This light was positioned slightly to the left of the camera to avoid shadows falling between the subjects. Photographed in the late afternoon sun. (**SUBJECT**—The Callahan family; **DATE**—1999; **CAMERA**—Mamiya RZ67; **FILM**—Fuji NPH, ISO 400; **LENS**—50mm)

CHAPTER FOURTEEN

THE HOLLYWOOD PORTRAIT

Some of the finest black & white portraits ever made were made of the Hollywood movie stars of the 1930s and '40s. Most were made by the Hollywood studio photographers. Two of the best were Clarence Bull and George Hurrell.

These photographers used 8x10-inch studio cameras with 16- to 18-inch lenses. The lighting equipment was spotlights, ranging from 750 to 2000 watt-seconds, and flood lights for fill. Some spotlights were on boom stands to get the light right over the subject's faces and to light their hair from the back. The film was Kodak Super X with an ASA speed of 100. The typical exposures ranged from about ½ second to 1 second at f-16 to f-32 to get the needed depth of field.

The subjects were usually propped in chairs or lounges to allow the stars to remain still for the long exposures and the twenty to thirty exposures made of each subject. The film was also heavily retouched with lead pencils.

Believing that there is still a great interest in black & white portraits today, I decided to begin offering Hollywood-style portraits to my clients. I was very pleased at the interest this style of image generated.

The film and equipment today is far superior to that used in the 1930s. I use the Mamiya RZ67 camera and the 140mm lens with the new Fuji Acros Black & White film (ISO 100).

For the images in this book, the film was developed and custom prints were made by H&H Color Lab. I used four to six Calumet 750 Travelite strobes for each portrait. The key light was usually a spotlight grid, but I also used 7-inch reflectors with barn doors, and umbrellas when needed.

FACING PAGE—My daughter Leslie draped Doty Giuliani and her daughter Tiffany in black material to give them a dramatic look. I used a 31-inch umbrella as the key light and a weak umbrella fill, set about three stops less than the key. Two skim lights from the right- and left-rear of my subjects lit their hair and Doty's near-profile. I use Polaroid 664 black & white film to check the lighting and exposure on all my black & white sittings. The exposure was $\frac{1}{125}$ second at between f-16 and f-22. (**SUBJECTS**—Tiffany and Doty Giuliani; **DATE**—2003; **CAMERA**—Mamiya RZ67; **FILM**—Fuji Aros, ISO 100; **LENS**—140mm)

ABOVE—After we began displaying Tiffany and Doty's black & white portrait, the style began to get popular. It appealed to this young married couple. The lighting used for this image is the same as was used in the portrait of Tiffany and Doty (previous page). (**SUBJECTS**—Angel and Karla Lopez; **DATE**—2003; **CAMERA**—Mamiya RZ67; **FILM**—Fuji Aros, ISO 100; **LENS**—140mm)

FACING PAGE—Doty looked like a Hollywood star to me, so I invited her back for a guest sitting. The lighting is the same as in the portrait of Doty with her daughter, except I used a grid on my 7-inch reflector as the key light, creating a look more like a Hollywood spotlight. For this style of lighting, I placed a weak umbrella fill behind the camera—close to the direction her nose is facing. I feel the general fill light, usually placed behind the camera, flattens the lighting pattern on my subject's face too much for this style of dramatic lighting. (**SUBJECT**—Doty Giuliani; **DATE**—2003; **CAMERA**—Mamiya RZ67; **FILM**—Fuji Aros, ISO 100; **LENS**—140mm)

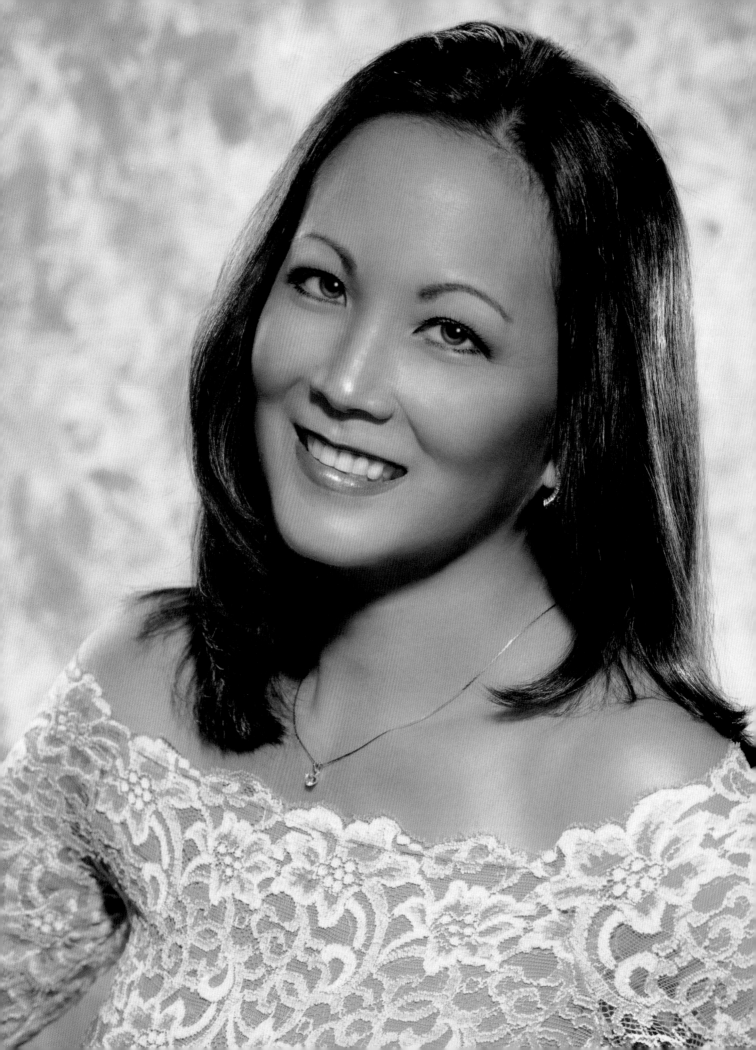

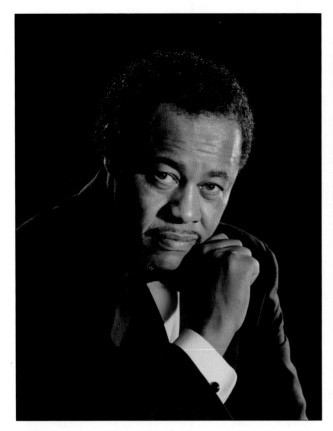 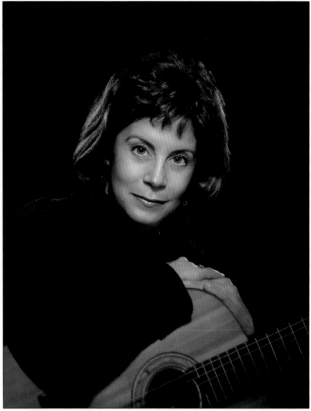

ABOVE LEFT—Ken is one of Virginia's top artists. He needed a portrait for a brochure, and I talked him into a Hollywood-style session. The lighting here is the same as was used in the portraits of Doty and Jeannie, except the key light was placed to create more of a loop-light pattern. (**SUBJECT**—Ken Wright; **DATE**—2003; **CAMERA**—Mamiya RZ67; **FILM**—Fuji Aros, ISO 100; **LENS**—140mm)

ABOVE RIGHT—JoAnn is the conductor of the Virginia Symphony and the Buffalo Philharmonic Orchestra and frequently gives solo performances with the guitar. The portrait is for a brochure highlighting her guitar performances. The lighting used in this image is the same as that used in the portraits of Doty and Jeannie. (**SUBJECT**—JoAnn Falletta; **DATE**—2003; **CAMERA**—Mamiya RZ67; **FILM**—Fuji Aros, ISO 100; **LENS**—140mm)

FACING PAGE—I have photographed Jeannie since she was a high-school senior. Between being a mother and wife, she has been a model for over twenty years. This portrait was made for a new modeling portfolio. The lighting is similar to the light used in the previous image, except the background is lighter and the key light was placed almost directly over her face. It is called butterfly light. No fill light was used, because her shoulders and white dress reflected enough light to give some detail in the shadows. Strobe was used on the background. (**SUBJECT**—Jeannie Wong Slaughter; **DATE**—2003; **CAMERA**—Mamiya RZ67; **FILM**—Fuji Aros, ISO 100; **LENS**—140mm)

CONCLUSION

From the beginning of photography over a hundred years ago to the early 1950s, there was a great deal of advancement in camera equipment, chemistry, and techniques. However, even in the 1930s, the large 8x10-inch studio camera was still the main camera. Tungsten portrait lights were still the standard, and strobe lights were just beginning to come on the market in the mid-1950s.

The advancements in photography since then have been truly revolutionary—portraits are being made today that one could only have dreamed of making in the 1950s. However, with all of the modern advancements we now have at our command, the basics of good portraiture are still the same as they have always been. Taste, good judgment, and a creative eye for design, color, and originality are still the cornerstones of the profession—we just have a greater range of choices today for creating more artistic work of a higher quality.

We are now able to make life-size portraits that compare favorably with fine paintings—and most of the time we can surpass them. Just about every community in the country has some huge new homes in the million-dollar price range that feature cathedral ceilings about twenty feet high; these can easily accommodate 40x60-inch (or even larger) photographic portraits. There are a few photographers in the country who have taken advantage of this market, but most have ignored it.

My legacy to my daughter and son-in-law is to help them develop this still relatively unexplored market. I believe photographers have done very well satisfying the needs of most of our customers. We just need to expand our horizons to reach these very high-end customers and expose them to the wonderful detail and authenticity of fine, high-quality photographic portraits.

INDEX